IMAGES
of America

KILLEEN

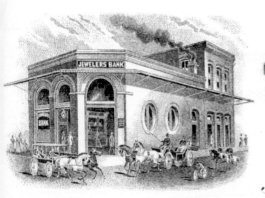

THE JEWELER'S BANK.

RESPONSIBILITY OVER $35.000 ⁰⁰

WILL RANCIER, Proprietor & Cashier.
SAM RANCIER, Asst Cashier.

Killeen, Texas, Aug. 8. 00

The Jeweler's Bank, founded by Will Rancier and his brother Sam about 1896, was Killeen's first bank. In 1904, it was consolidated with First National Bank, whose directors named Will Rancier president. Brother Sam became cashier. (Courtesy of Michael and Nancy Kelsey.)

ON THE COVER: As construction on Camp Hood began in 1942, automobiles crowded the small, adjoining town of Killeen, Texas. Traffic became so heavy that motorists were parking in the middle of one of the town's main streets, Avenue D. This marked the beginning of Killeen's conversion from an agricultural-based economy to a military-based one. (Courtesy of the Killeen Area Heritage Association.)

IMAGES
of America

KILLEEN

Annette S. Lucksinger
and Gerald D. Skidmore Sr.

ARCADIA
PUBLISHING

Published by Arcadia Publishing
Charleston, South Carolina

Printed in the United States of America

Library of Congress Control Number: 2012940086

For all general information, please contact Arcadia Publishing:
Telephone 843-853-2070
Fax 843-853-0044
E-mail sales@arcadiapublishing.com
For customer service and orders:
Toll-Free 1-888-313-2665

Visit us on the Internet at www.arcadiapublishing.com

CONTENTS

ACKNOWLEDGMENTS

Many deserve our thanks for their help in the preparation of this book. They range from those who shared memories and historical photographs to contemporary technologists who have mastered the intricacies of cyberspace.

The work of both the late Gra'Delle Duncan (author of several books on Killeen and Central Texas history) and the late Robert L. DeBolt (longtime Killeen professional photographer who recorded not only the happenings of his day but also copied many historic photographs) contributed greatly to this book. The late John Carter's drawings are welcome additions.

Thanks go to Wilma McClung Smith, who let us copy prized photographs. Annie Roe Bowen Buckley, Windy and Sue Hallmark, Jean Bowen Ray, and the late Woodrow and Toncie Bowen Young have added priceless information to our effort.

We received special assistance from Todd Martin, Nancy Kelsey, Carmen Woods, Hilary Shine, Connie Kuehl, Tim Tidwell, Henry Lucksinger, Jeff and Martha Heckathorn, David Perez-Guerra, Cae Carter, and David Miller. Files of the Killeen Area Heritage Association turned up a number of heretofore unpublished photographs. Our special thanks are due to those who have made contributions to this organization, which was created in 1983 to preserve and share Killeen's colorful history. Photographs also came from the archives of the *Killeen Daily Herald*, the Killeen Public Library, the City of Killeen, and the US Army, although the particular origins of many have been lost over time.

We are truly grateful for the assistance—and patience—of Arcadia editor Laura Bruns, who quickly understood that she was working with two old-school journalists who have not fully adjusted to new publishing technology.

Historical publications consulted include *Killeen: A Tale of Two Cities*, by Gra'Delle Duncan, 1984; *Bell County Revisited*, by Martha Bowmer, 1976; *Fort Hood: The First Fifty Years*, by Odie B. and Laura E. Faulk, 1990; *Historic Killeen: An Illustrated History*, by Gerald D. Skidmore Sr., 2010; *Unforgettable Decade: A Pivotal Era*, Killeen Project 1930s, 1993; and the Ding Dong Diary columns by Gra'Delle Duncan, published in the *Killeen Daily Herald*, 1980s.

Finally, we must acknowledge the generosity of many Killeen-area residents who have lent family photographs to be copied and archived. These pictures provide invaluable information about the city's past and now may be shared with each new generation of Killeenites as well as with visitors to the city. Unless otherwise noted, all images appear courtesy of the Killeen Area Heritage Association.

This project has been supported, in part, by City of Killeen Hotel Tax Revenues.

INTRODUCTION

April 15, 1950, was a red-letter day in the life of Killeen, Texas. It was the day that the Army General Staff made Camp Hood a permanent installation and redesignated the military post as Fort Hood. That act changed the course of life for Killeen's residents and established that the Central Texas town would permanently switch its pre–World War II, agricultural-based economy to a military-based one.

Residents were already used to having the military around. In 1942, the vast acreage west and north of Killeen was selected as the site for a Tank Destroyer Center, a training ground to teach US soldiers how to defend against the destructive German tanks that were running roughshod in Europe. The new camp was named Hood in honor of Confederate general John Bell Hood, who commanded Hood's Texas Brigade for a short time during the Civil War. The military installation claimed the land of some 300 farming and ranching families. It also meant that Killeen would be overrun with civilian workers building a new Army post and, eventually, with soldiers and their families as well. At times, the population of Camp Hood—made up of soldiers and civilian workers—would exceed 100,000.

That was a far cry from the town that was founded by the Gulf, Colorado & Santa Fe Railroad on May 15, 1882, as the railroad extended its tracks from Temple westward toward Lampasas.

A small but enthusiastic crowd was on hand as the first train pulled into the newly designated town, which already boasted three stores, all facing the railroad. As the crowd cheered and threw hats into the air, one cowboy even roped the train's smokestack.

If the crowd expected to see the town's namesake, they were most likely disappointed. Frank Patrick Killeen, a native of Ireland and an official of the railroad, apparently never set eyes on the town, located just west of the Balcones fault line and an eastern entry to Texas Hill Country.

With the excellent farmland and ranch land that surrounded the new town, it did not take long for Killeen to establish itself as a thriving agricultural center. With the railroad an integral part of the town and fertile lands making farming a lucrative business, King Cotton soon prevailed, and Killeen became a major shipping point to Gulf Coast markets. Wool also was an important product that helped ranchers prosper.

The town proper, incorporated in 1883, faced all the problems of any frontier town. The streets were rutted and often muddied, and there was no water system, no sewer system, no telephone service, no electricity, and a lack of natural gas. Once residents began purchasing the new transportation vehicle, the automobile, the street problems increased.

It was in the 1930s that the Works Progress Administration (WPA) finally assisted the city in paving downtown streets and graveling others. Killeen got its first telephones in August 1900, and a power plant was approved in November 1905. In February 1912, Killeen voted 74 to 14 to build a waterworks for the town and, in 1925, voted to expand the water system and add a sewer system.

During its pre–Camp Hood years, Killeen's population held steady at about 1,200. In 1950, the year Camp Hood was declared a permanent installation and renamed Fort Hood, the population

stood at 7,045. Then, the city boomed. By 1960, the U.S. Census Bureau placed the population at 23,377; 1970, 35,507; 1980, 46,266; 1990, 63,535; 2000, 86,911; and 2010, 127,921. The 1970 figure officially made Killeen the largest city in Bell County, surpassing Temple.

In addition to spurring population growth, the presence of the giant military installation also was credited with making Killeen one of the most diversified cities in the state.

One

UNCHARTED FRONTIER

HARDY SOULS ENDURE EARLY HISTORY

Before the train came the people. Before the people was the land, lush with prairie grasses and stands of live oaks, and the many varieties of animal life, including deer, bison, bobcats, and the occasional ocelot. Native Americans followed the game, hunting, making weapons of plentiful chert, and trading along ancient trails.

The landscape along the Balcones Escarpment lay at a juncture of Texas's three major physical regions: the Edwards Plateau, the Cross Timbers, and the Blackland Prairie. Fairly squat, flat elevations, called "mesas" by the Spanish, formed the most distinctive feature, with miles of open land between; early white settlers tended to call them "mountains:" Cross Mountain, Sugar Loaf Mountain, Horsethief Mountain.

But it was land, not scenery, which attracted white settlers. They came and began new lives—mostly farming and ranching—after the Civil War's devastation. Those hardy souls were isolated in communities like Palo Alto, settled about 1872, or Youngsport, which got a post office in 1871. The war had barely touched the area, though east Bell County had been deeply involved.

Other white settlers had arrived even earlier. The Lawler family, who lived on the Lampasas River south of present-day Killeen, missed out on the 1836 Runaway Scrape, the mass evacuation of Texas after the Texian defeat at the Alamo. The Cross family settled on the Bell-Coryell County line before the Civil War. Sugar Loaf (settled in 1852), Pidcoke (settled in 1857), Eliga (settled in the 1850s), and Oakalla (also settled in the 1850s) were all in early Killeen's trade area.

The federal government established Fort Gates in 1849 to protect settlers from Native American attacks, then closed it in 1852. But at Sugar Loaf, the Riggs family, newly arrived from Arkansas, fell victim to an Indian attack on March 16, 1859. John and Jane Riggs were murdered, and their two little girls, Rhoda and Margaret Ann, were kidnapped. Two neighbors were also killed. After escaping from the Indians, the girls and two younger brothers, hidden in tall grass, were rescued. A transitional zone, the countryside destined to become Killeen, located some 20 miles west of the Chisholm Trail, occasionally attracted other dangerous types who were eager to travel away from the main north-south route, especially in the often lawless years after the Civil War.

In this sketch, the late artist John Carter captured the essence of a farm near Killeen that stood until the second half of the 20th century. Such sketches, along with his well-known watercolors,

have endeared Carter to those who like to remember what the Killeen area was like before the coming of the railroad—rough, rural, and rigorously independent.

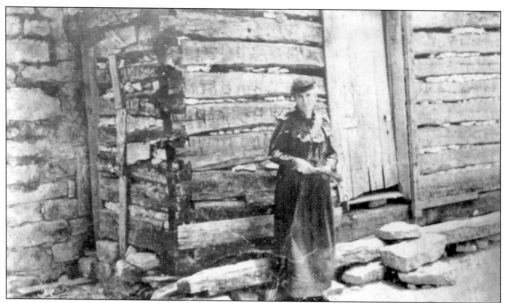

Mary Ann Chambers stands beside the remaining half of a dog-run cabin built in 1863 by her husband, John C.G. Blackburn, near Palo Alto, now part of Fort Hood. Moved twice, the cabin now rests at the Killeen Community Center, at the corner of W.S. Young Drive and Veterans Memorial Boulevard. The Blackburns are buried at the Blackburn Cemetery in northeast Killeen.

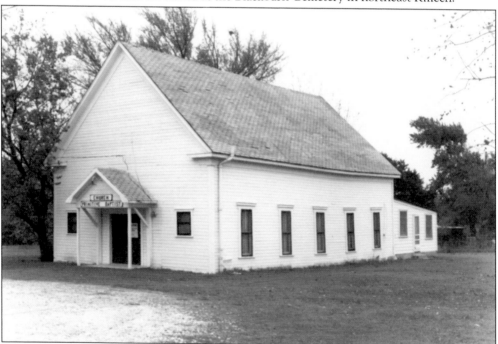

Bethel Primitive Baptist Church, originally located three-and-one-half miles north of Killeen in Palo Alto, is recognized as Killeen's oldest church building. After the Santa Fe railroad reached this area, church leaders paid $50 for two acres of land next to Nolan Creek, and the church was moved to this site. When membership dwindled to six in 1991, the church was deeded to the Killeen Area Heritage Association.

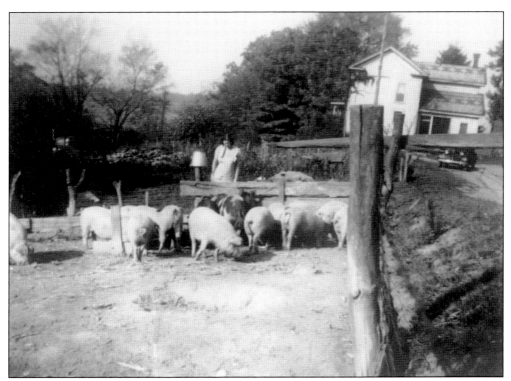

Like many early farms in the Killeen area, this family's spread consisted of sheep and pig pens, a house probably enlarged as the farm began to prosper, and even an automobile. Killeen's agricultural tradition continued until the 1950s, when many residents' backyards still housed a cow or a horse and, in some cases, a privy.

Before the train arrived, bringing markets for cotton (which would become the area's most profitable product), sheep raising was probably the most widespread commercial activity among early settlers. Sheep shearers often came in the spring to assist in the work, before summer's heat arrived. Killeen lies on the edge of the Edwards Plateau, long the nation's most important wool and mohair locality.

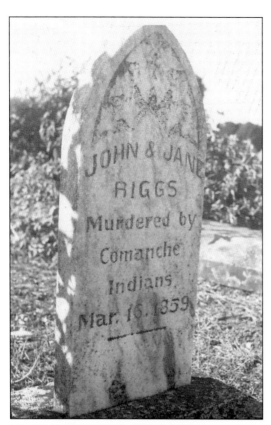

When more than 300 families were displaced with the building of Camp Hood, many gravesites found new homes at Killeen City Cemetery. Among them were the graves of John and Jane Riggs, killed March 16, 1859, in the Riggs Massacre at the Sugar Loaf community, the last-known fatal Indian attack in the Killeen area. Some 464 Sugar Loaf graves are now located in the cemetery's Evergreen area.

Killeen's first marshal was James Benton Blair (second from the left), who served at least 10 years. Other Blair relatives also served as marshal: John T. Blair (far right) was killed in 1917, and George Nichols Blair (second from right) replaced his slain brother. Also in this 1915 photograph are Luther L. Blair (far left), Mattie Leah Blair, and Joel Dyer Blair (third from right). (Courtesy of the Killeen Police Department.)

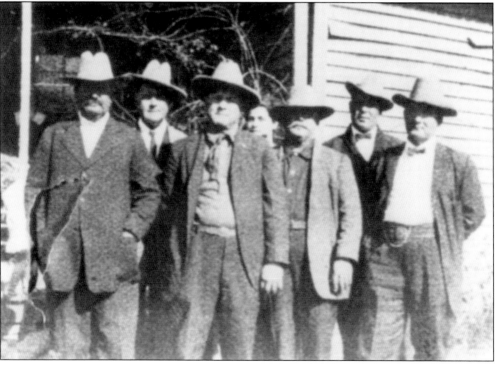

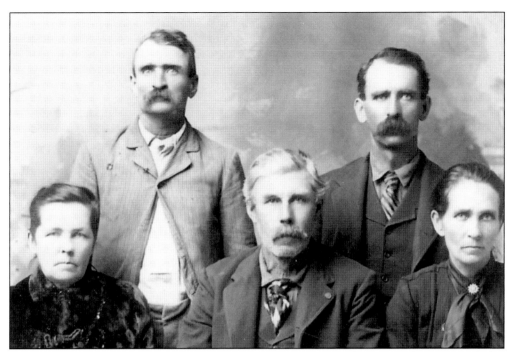

Survivors of the March 16, 1859, Riggs Massacre met with other family members at Anadarko, Oklahoma Territory, in 1904. Pictured above are, from left to right, (first row) Rhoda Riggs Conover, A.C. Conover (Rhoda's husband), and Margaret Ann Riggs Benton (Rhoda's sister); (second row) Brannick Riggs (a cousin of the Riggs siblings) and William Carroll Riggs (younger brother of Rhoda and Margaret). Killed in the raid were the siblings' parents, John and Jane Riggs, and two neighbors. The six men pictured below were credited with the rescue of four Riggs children after the attack. They are, from left to right, (first row) J.G. Blackburn, Ambrose Lee, and Thomas Elms; (second row) Robert Chalk, John Griggs, and a Mr. Lamb.

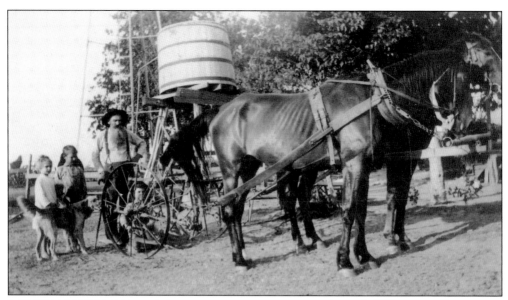

An early Killeen-area farm required several ingredients: a windmill and cistern to store precious water, a plow (with horses or mules, if the family was lucky), experience (in the form of the older generation), a dog or two, plus, of course, children to help with the chores when they were not in school—if a school were available.

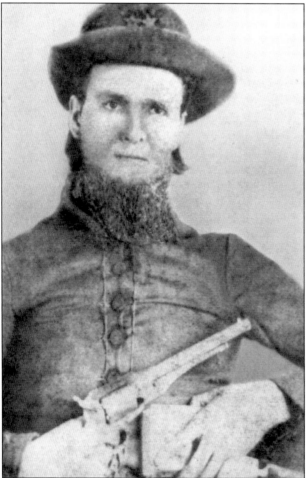

One of many Civil War veterans who came to the Killeen area in the post-1865 years, William Houston Parmer was an Arkansas native who served with the 11th Texas Cavalry, one of the most active Texas units in the conflict. Described as a cowboy and farmer, he was the father of 13 children, 12 of them by his second wife. He is buried at Live Oak Cemetery near Youngsport. (Courtesy of Sue Williamson Hallmark.)

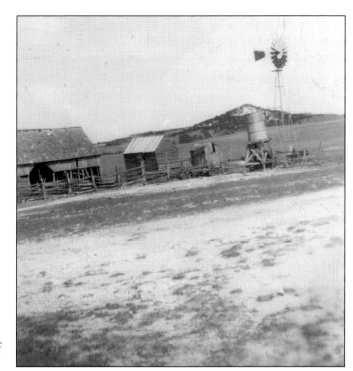

The Thomas Elms farm at Sugar Loaf, typical of farms near the future town of Killeen, encompassed a view of 180-foot Sugar Loaf Mountain. In the second half of the 20th century, the Killeen Independent School District began naming new schools in memory of rural schools that no longer existed. Sugar Loaf Elementary School opened in 1965. Other schools named in this manner include Brookhaven, Maxdale, Palo Alto, and Willow Springs. (Courtesy of Wilma McClung Smith.)

Killeen's neighboring city Harker Heights purchased 20 acres in summer 2012 to preserve the site of Bill Alford's Comanche Gap. According to Harker Heights city manager Steve Carpenter, the city plans a historical park with a museum, walking trails, and picnic areas. The area has long been considered to be the place where Comanches abandoned two young Riggs girls after the raid on their family's farm at Sugar Loaf.

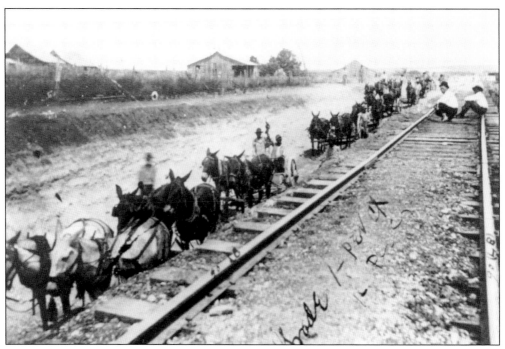

Men and mules work together to build the railroad in the Killeen area. The coming of the Gulf, Colorado & Santa Fe Railway Company to the isolated area would dramatically change the countryside and advance Killeen's economy by providing access to markets for agricultural products.

This area's earliest settlers surely did not dress like rakish Ike Cox, who arrived the year after the train came. They could, however, look forward to being able to buy up-to-date fashions, as well as more essential goods, once their communities were connected to the rest of the nation and relieved of their frontier isolation. Cox was Killeen's first barber and Texas's oldest active barber when he died in 1950 at age 93.

Two

LIVELY BEGINNINGS
THE RAILROAD CREATES A TOWN (1882)

As the first train reached Killeen on May 15, 1882, William "Wild Bill" Scoggins jumped aboard the cowcatcher, rode a short distance, jumped off, grabbed a lariat, and roped the smokestack of the locomotive. The new town got off to a lively beginning.

Soon after this official founding, Killeen began to develop into a real town—a frontier town to be sure, with saloons and occasional shoot-outs. Population increased as people moved in from nearby communities. Quickly established were more businesses, a post office, churches, the first school, and a pioneer-type social life.

The first child born in the young town, a baby girl, arrived in October of that year. However, her parents did not claim the prize the railroad offered for Killeen's firstborn. They passed on the money because of a stipulation by GC&SF that, in order to claim the $75 town lot, the child must be named Frank Patrick Killeen (in honor of the assistant general manager for the railroad and the town's namesake). The girl's parents decided that was not a proper name for their daughter, so the honor and the prize went to a boy born about a month later.

In 1893, residents of Killeen voted to incorporate in order to bring order to the town and provide law enforcement. Aldermen and a mayor were elected, along with a town marshal. Marshal James B. Blair reinforced the frontier ambiance by shooting and killing the town's doctor, a crime for which he was found not guilty by reason of self-defense. His brother John T. Blair, who later became a marshal, was shot and killed while trying to settle a dispute between two families.

Church members managed to close down the saloons, and the new government brought some order to the town, allowing it to prosper and establish itself as a major shipping point for agricultural products. Town fathers then began to concentrate on pressing problems; there were muddy streets and poor sidewalks to address, along with unsanitary conditions (presented by outdoor toilets), roving livestock, and the question of taxes to fund the government's meager operations.

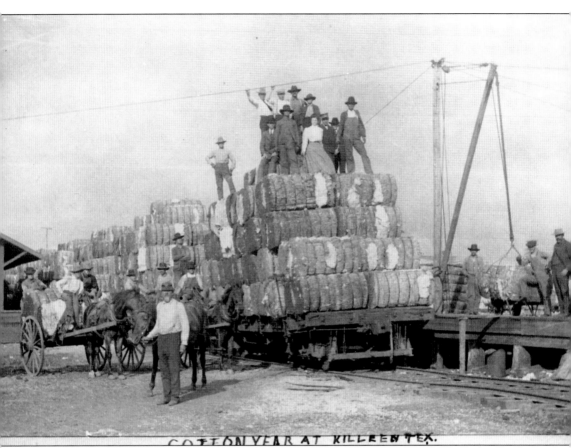

COTTON YEAR AT KILLEEN TEX.

Stacks of cotton bales loaded on railcars were a common sight in Killeen, as this 1905 photograph indicates. For many years, cotton was the most important crop for the town, which grew into a major shipping point for agricultural products, especially cotton and wool. Records indicate that 1919 was the town's most productive year for cotton with 10,000 bales ginned.

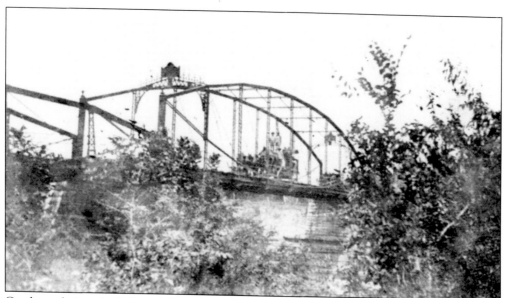

Creeks and rivers in Bell and Coryell Counties frequently hit flood stage, blocking low-water crossings and preventing farmers and ranchers from getting their produce and animals to market. The construction of iron bridges, like this one, helped solve that problem, allowing Killeen to become a thriving agricultural center.

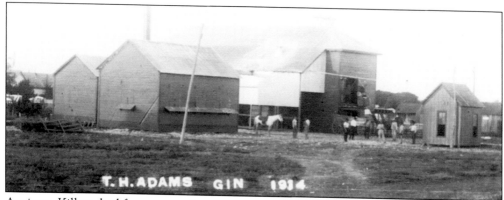

At times, Killeen had four cotton gins operating, sometimes turning out cotton bales 24 hours a day. Cotton was really king in Killeen for many years. The Adams gin, pictured here in 1914, was one of the longest-surviving gins.

Even youngsters participated when the Killeen area's principal crop, cotton, was ready to harvest. Their tailor-made sack allowed them to pull the load they had picked. Ducking sacks could be purchased, but most farmers bought ducking material and women sewed the sacks. These would be reused for multiple seasons, often requiring patches on the side that dragged on the ground. Ducking is a heavy cotton fabric used for tents, tarpaulins, and, of course, cotton sacks in the old days.

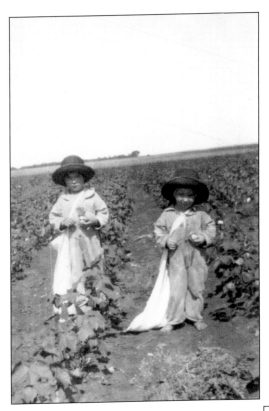

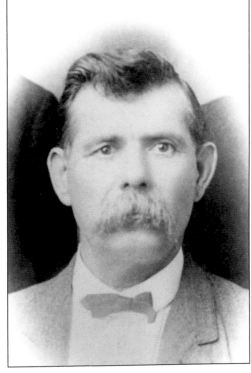

Dr. W.H. "Billy" Atkinson, who moved from Florence to Killeen in 1882, was the father of the second child (and first boy) born in Killeen. Fulfilling a requirement to claim a $75 town lot offered by the railroad, Dr. Atkinson and his wife, Mary, named their son Frank Patrick Killeen Atkinson, a name the parents of the first child born in town did not find appropriate for a girl.

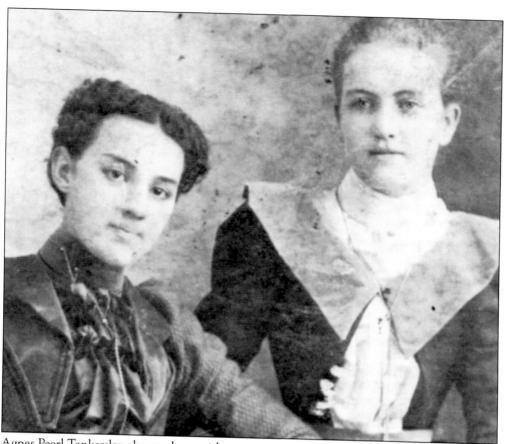

Agnes Pearl Tankersley, shown above with sister Louella (it is unclear which is which), was born on October 5, 1882. Her parents, Agnes and Lee J. Tankersley Jr., declined the railroad's offer of a town lot for the town's firstborn because of a stipulation that the baby must be named Frank Patrick Killeen. At right are Pearl's father and his second wife, Bea Andrews.

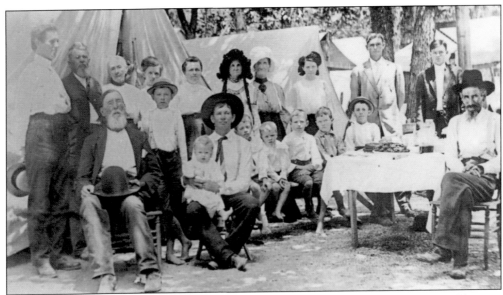

These campers are enjoying one of the most peaceful sites in Bell County. For over 100 years, beginning in 1885, the Nolanville Church of Christ Encampment was held on these grounds. Teaching, preaching, and fellowship filled the 10 days in August as people (sometimes as many as 1,000) came from a 100-mile radius to attend the event. The last encampment was held in 1996.

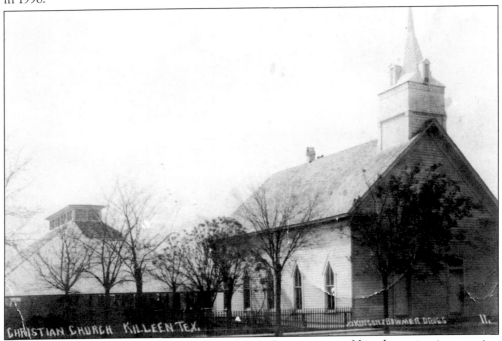

Established about 1884, the Christian Church in Killeen was one of four denominations serving the newly established town. The church met in the school until a frame building was constructed in 1893 between Second and Fourth Streets, just north of Avenue A. A tabernacle was erected in 1900, the auditorium was enlarged in 1914, and a new sanctuary was built in 1952. In 1993, the church moved to new facilities on North W.S. Young Drive.

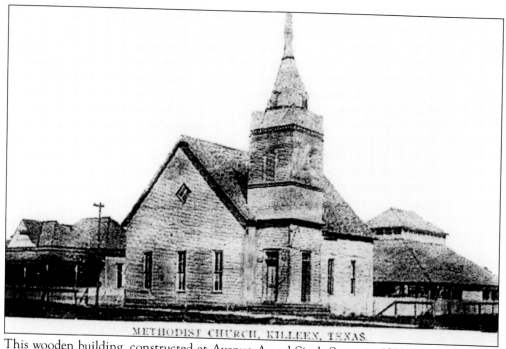

METHODIST CHURCH, KILLEEN, TEXAS.

This wooden building, constructed at Avenue A and Sixth Street in 1890, housed the First Methodist Episcopal Church South of Killeen, later known as First United Methodist Church. The congregation had initially begun meeting in a small school building the year Killeen was founded. In 1912, a new building was erected; it later became the church's fellowship hall when another new sanctuary opened in 1960. In 2011, the congregation relocated to a new 24-acre campus on Elms Road.

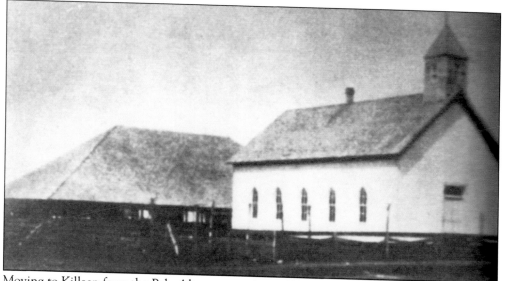

Moving to Killeen from the Palo Alto community in 1883, the First Baptist Church of Killeen met in temporary facilities until the wooden church, pictured above, was built in 1892. In 1917, a building was constructed of red bricks at Green and Fourth Streets, and educational facilities were added. This campus served the church until 2009, when a new facility opened at 3310 South W.S. Young Drive.

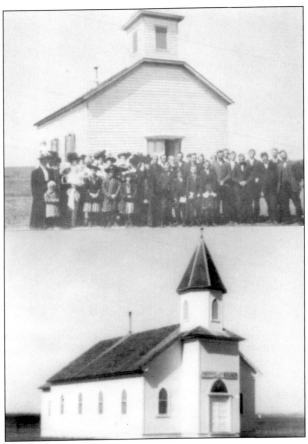

To serve German settlers south of Killeen, the German Evangelical Lutheran Emmanuel Congregation was organized in 1889 and constructed this frame building (top) in 1892 with a larger structure (bottom) erected in 1924. Now known as the Immanuel Lutheran Church, the congregation moved into Killeen in the 1940s, although a Lutheran cemetery remains at the original site.

This photograph, taken September 16, 1897, depicts one of the major religious and social events of the period: a baptizing ceremony in Nolan Creek. Families, friends, and church members lined the banks of the creek to watch as a minister baptized new converts.

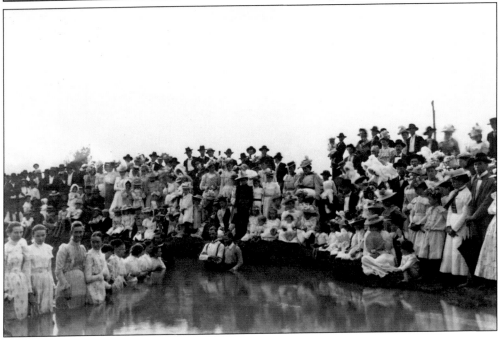

Elder W.Y. Norman, a Primitive Baptist minister, was the patriarch of a family that figures prominently in Killeen's business and civic history. Elder Norman was the father of 22 children by three of four wives. He last married at age 81 and outlived all four wives, dying in 1939 at the age of 92.

The California, Killeen's first hotel, opened in 1883. It was owned by Capt. John Richardson and his wife, Mary. The couple, along with their adopted daughter Emma, had moved to Texas from California. The two-story hotel, which had 10 rooms, was located on the north side of Avenue D, just east of the Eighth Street intersection.

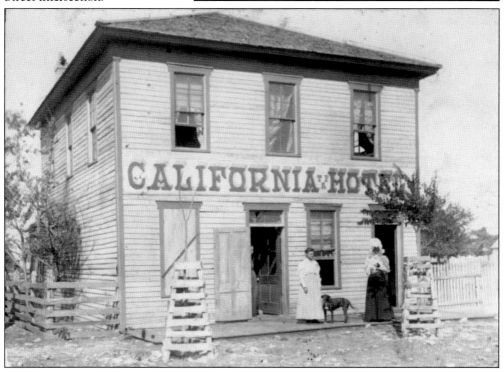

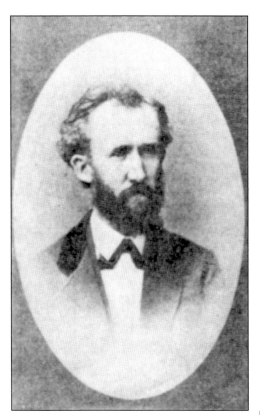

Aside from founding the town's first hotel, former Union officer Capt. John E. Richardson also served as one of Killeen's early postmasters. After his death, he was succeeded by his wife, Mary. Their daughter Emma was married to the town's second doctor, Joseph B. Fitzpatrick.

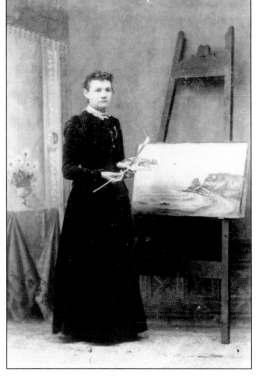

Mary H. Richardson, who, with her husband, built Killeen's first hotel in 1882, is credited with being Killeen's first businesswoman. In addition to her work with the hotel, she succeeded her husband as the town's postmaster. Multitalented, she was also an artist and the owner of the town's only parlor organ, which she sometimes lent to churches.

Eugenia Fitzpatrick, the 10-year-old daughter of Dr. J.B. Fitzpatrick and Emma Richardson Fitzpatrick, was all dressed up for this 1901 studio portrait. Eugenia, who never married, worked for the Killeen Independent School District for many years and became affectionately known as "Miss Genie."

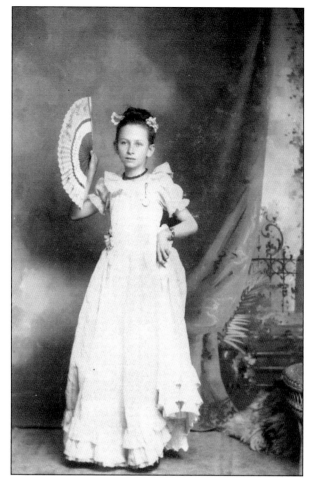

Most of the men in early Killeen were volunteer firemen, but they were unable to quench this destructive 1920 fire, which hit businesses on Sixth Street between Avenues D and C. Parked at the scene is the town's first fire truck, a refitted touring car.

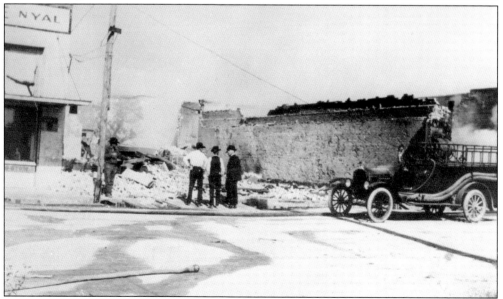

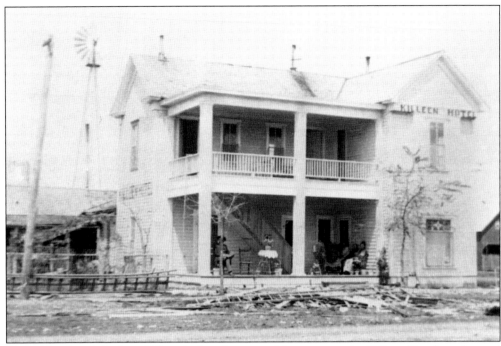

One of four hotels built in Killeen before the turn of the century, the Killeen Hotel was located on the northwest corner of Avenue D and Eighth Street. Erie Stovall and her mother had a successful home restaurant and added the hotel after requests by their customers. The hotel, later run by Bertie Cox, was still operating at the beginning of World War II.

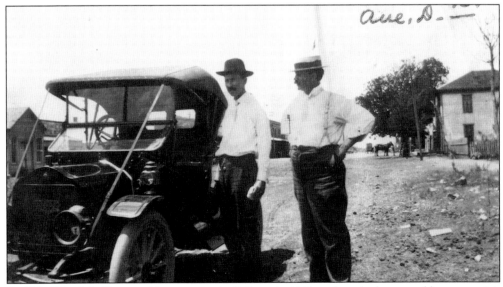

Dr. D.L. Wood (left) opened his practice in Killeen in 1901 and used a horse and buggy to visit patients in the country. He was one of the first in town to purchase an automobile. Dr. Wood, who also owned Wood's Drug Store, was active until his death in 1942. He and R.T. "Top" Polk (right), a postmaster and four-time mayor, are pictured in front of the Killeen Hotel with what is presumably Dr. Wood's automobile.

Horse-drawn vehicles found real challenges on the road with the advent of automobiles. This photograph, taken around 1915, shows Dr. W.E. Spivey behind the wheel of his automobile. Pictured in the back seat are, from left to right, Jim Hubbard, Charlie Hairston, and Horace Law. The front-seat passenger is unidentified.

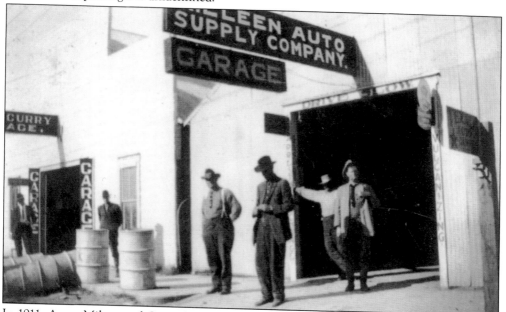

In 1911, Avery Milner and Conrad Black opened Killeen's first automobile dealership, Killeen Auto Supply Company, selling Fords. At the time, the automobile had not yet been fully accepted, and many considered the dealership a risky business. However, according to an old newspaper report, the business did well, especially "after the delivery of several swanky, brass 'radiatored' Model T's."

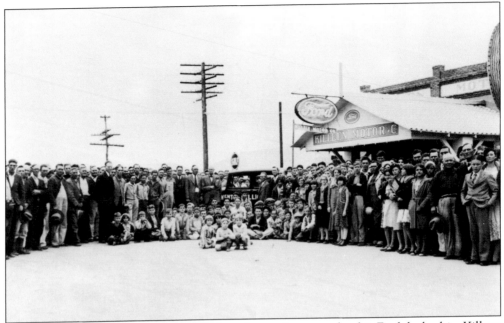

In business in the early 1930s, V.D. Slaughter drew quite a crowd to his Ford dealership, Killeen Motor Company, by giving away an automobile as a Trades Day promotion. The Marvin Fergus family later operated the Ford dealership, then Hugh Statum took a turn, then Dan Green had Centroplex Ford, and, in 2012, Ford was a part of Automax dealerships.

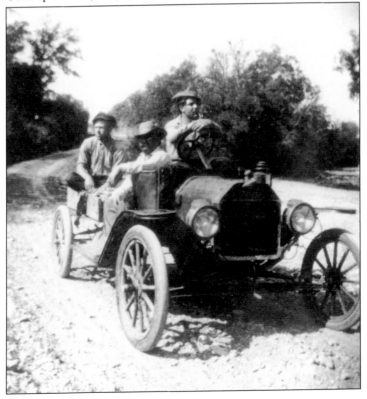

These three men—Conrad Black (rear, with cap), Luther Blair (center), and George Blair (driver)—quickly recognized a good use for the newly invented automobile: hunting. Hanging from the side of the car is a lone, almost unrecognizable duck, surely not their only kill for the day.

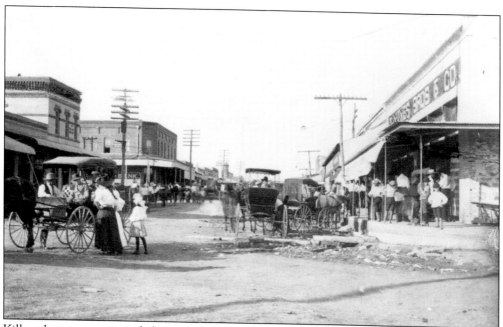

Killeen became very crowded as rural residents came into town to take advantage of the bargains offered on Trades Day. In 1912, a photographer, looking north from the railroad tracks, captured this scene at Avenue D and Sixth (now Gray) Street. Cheeves Bros. & Co. is at the right, and the *Killeen Herald* is partially hidden by the buggy at left.

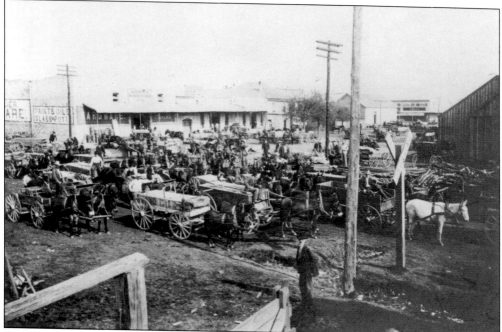

As Thanksgiving and Christmas approached, Killeen set aside Turkey Day. Farmers' wagons filled the town's wagon yard, and residents shopped for their holiday dinners' main dish. Turkeys were then fattened in backyards. All those wagons made finding parking space difficult, creating Killeen's first traffic jams.

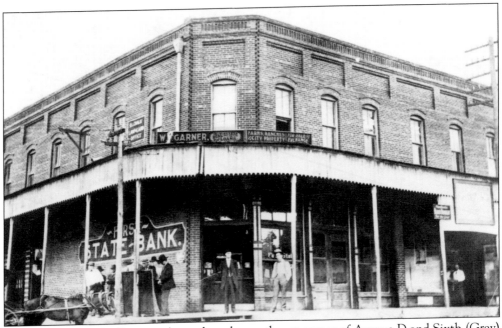

First State Bank of Killeen was located on the northwest corner of Avenue D and Sixth (Gray) Street. According to uncertified information from the Texas Department of Banking, the bank opened on September 23, 1907, and closed December 31, 1934, when it merged with First National Bank of Killeen, becoming Killeen's only bank at the time.

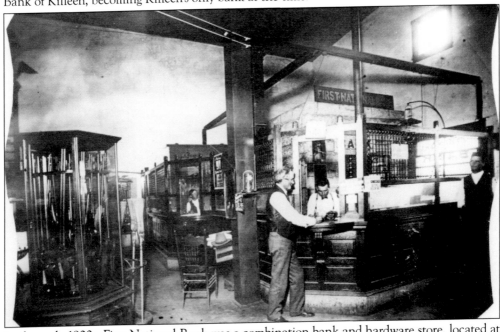

In the early 1900s, First National Bank was a combination bank and hardware store, located at Avenue D and Fourth Street. It was owned by Will Rancier, who was president of the bank from 1904 to 1919. Pictured here, Spencer Young, a pioneer businessman, is transacting business at the counter. The cashier is Will Rancier's brother Sam. Brooms and a case of guns are visible to the left in the hardware section of the store.

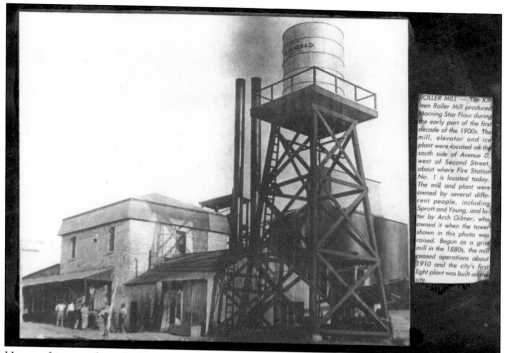

Home of its own brand of flour, Columbia, the Killeen Roller Mill played an important role in the life of Killeen. Built in the 1880s as a gristmill, it gained an elevator and ice plant and was recognized by its distinctive smokestack. The mill operated until about 1910, when the town's first power plant was constructed on the site. The newspaper clipping is an early caption.

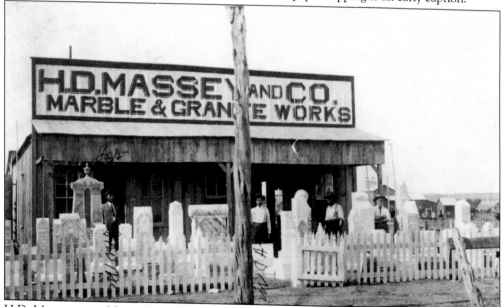

H.D. Massey moved his wife and son Earl from Maxdale to Killeen in 1902, establishing the H.D. Massey Marble & Granite Works, a business he operated for 19 years. In 1914, he built the adjoining Texas Theatre. The theater was the town's second and survived until the 2000s. Son Earl eventually became theater manager.

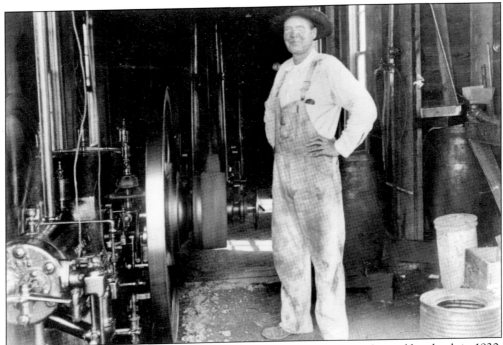

R.J. "Bob" Adams, Killeen's first water superintendent, served in that role until his death in 1930. Pictured here around 1915, he exhibits the town's first pump station. Killeen voted its first bond issue for a water supply system in 1914 and leased two wells for the water supply. One was a hand-dug well about 25 feet deep; the other was a drilled well about 900 to 1,000 feet deep.

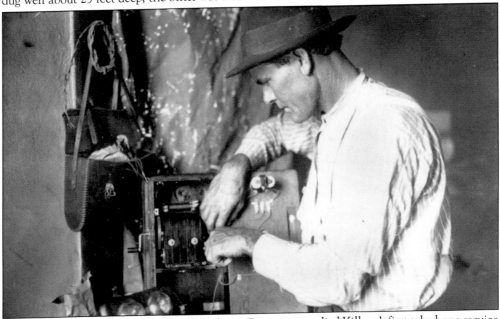

D.C. McDowell and his Independent Telephone Company supplied Killeen's first telephone service in 1900, with Dr. U.H. Nixon receiving the first two phones—one at home and one at his office. In this photograph, made about 1910, James Monroe Harbour, a company employee, repairs a hand-cranked telephone. Harbour's mother, Ella, and his sister Marie Perry served as operators.

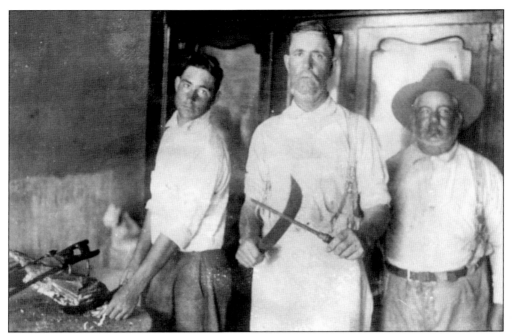

Early Killeen butchers look as though they could handle anything that came into their shop—even a robbery or an irate customer. These fellows were more than likely involved in the entire butchering process, from the time the meat was still "on the hoof" until it was trimmed, packaged, and handed to the purchaser.

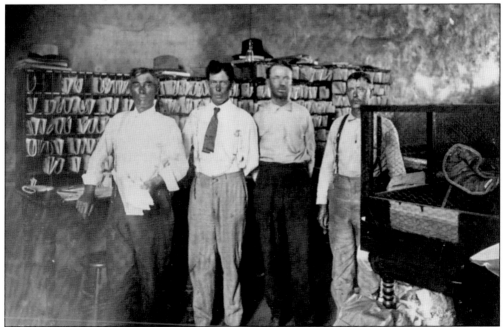

The job of rural mail carriers was made difficult when inclement weather rendered roads almost impassable. However, most took their task seriously, going out of their way to accommodate families on their routes. In this June 5, 1916, photograph are, from left to right, John Dooley, York Duncan, John Dwyer, and U.B. Brewster. Free rural mail delivery began in 1900.

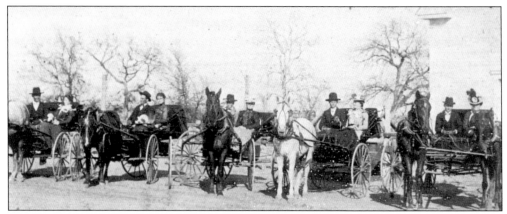

Entertainment opportunities were simple compared to those enjoyed today, the most popular being parties, watermelon feasts, fishing, baseball games, and buggy rides. These courting couples gathered one day in the late 1890s in front of the Bethel Primitive Baptist Church on South Sixth (Gray) Street as they prepared for a Sunday afternoon outing.

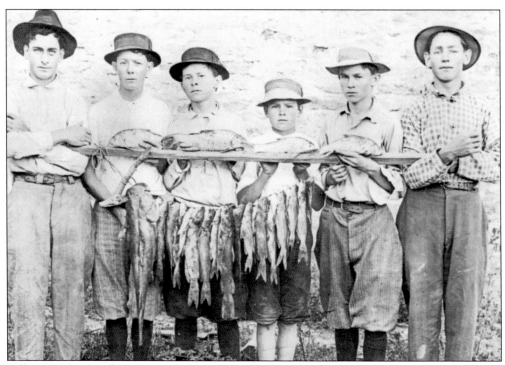

Killeen's Nolan Creek swimming hole was good for more than just swimming and baptizing. It was also a good place to catch fish. Showing off their catch in 1908 are, from left to right, T.J. Cloud, Barton Atkinson, James Graydon Cole, Joe Cramer, Earl D. Massey, and Eugene Ledger.

Three

KILLEEN'S DEVELOPMENT
PHOTOGRAPHS RECORD PROGRESS

As in most railroad towns, Killeen's downtown business community began near the Santa Fe railroad track with Avenue D serving as the town's main shopping street for decades.

Trades Day occasions brought shoppers from a trade area that extended north, south, east, and west. A barrel at the intersection of Avenue D and Sixth (now Gray) Street served as a traffic signal of sorts, helping drivers of wagons and buggies as they strove to avoid collisions.

Stores, hotels, and, naturally, saloons began opening soon after the arrival of the train, some even earlier. Many of Killeen's earliest structures stand today alongside buildings from the 1950s and onward; preservationists have pointed out that these newer businesses form architectural contrasts appropriate to a place known for its "two cities." Killeen's elevated sidewalks also recall its past, and with just a little imagination, one can stand at Gray Street and Avenue D, downtown's main intersection, look west, and conjure the frontier town Killeen used to be.

People regularly visited the depot, either to catch the train or to see who was arriving. Saturday afternoons were a favorite time to shop and visit downtown, and women dressed for such outings as if for church.

Residents built homes downtown before automobiles became commonplace. Others built homes on land near Killeen, which would be abandoned or moved into town when Camp Hood arrived in 1942.

In wet weather, muddy streets created problems, particularly when women's skirts still reached their ankles. Killeen High School's 1913 valedictorian, Emma Normand, described the mud in her senior diary, saying, "This town is muddy, muddy, muddy—m-u-d-d-y, and the dirtiest mud that ever deserved the name of mud."

The main route from Copperas Cove to Belton snaked through downtown Killeen from the west, turning onto Avenue D, then Sixth Street, then north to Rancier Avenue, and finally to the Hay Branch community and points east. A round-trip to Belton with a wagon and team required a full day.

Change would come, but in the early decades of the 20th century, Killeen remained small, friendly, and always ambitious.

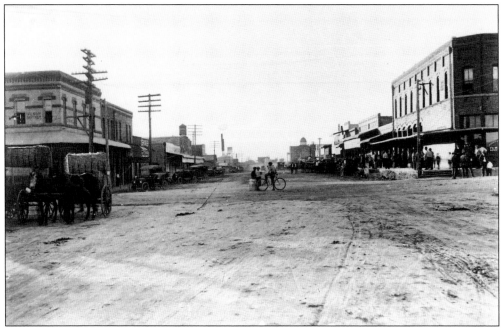

The barrel in the middle of the intersection of Avenue D and Sixth Street (now Gray Street) marks the busiest area of town during the early decades of the 20th century. Looking west on Avenue D, the photographer catches three important Killeen landmarks: the 1902–1903 brick school building, the water tower, and Killeen's roller mill.

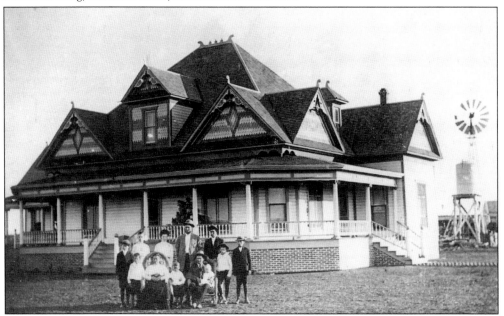

In 1909, the Andy Alonzo Sutton family occupied this impressive home just outside Killeen's town limits. Andy Sutton and his wife are seated in chairs with other family gathered around. Children in the family included Noel, Jewell, Della, Jesse, Harlan, R.G., Powell, Basil, and Alleen. Albert Wills, also shown, married Della. Harlan (first row, left) served many years as precinct four county commissioner.

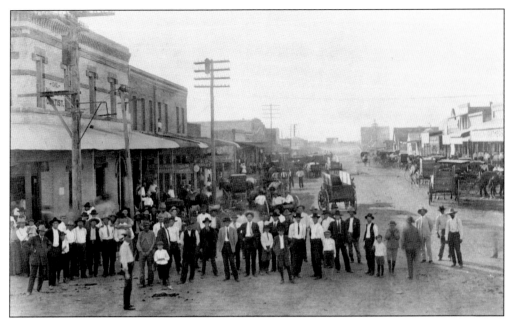

According to the late Robert DeBolt (Killeen's preeminent photographer for four decades), itinerant photographers, arriving by train, typically made images of townspeople and businesses in the morning and then, renting a room, took portraits of individuals, couples, and families in the afternoon. Subjects lined up for this c. 1904 photograph are standing on Avenue D. In the distance, to the west, is Killeen's first brick school.

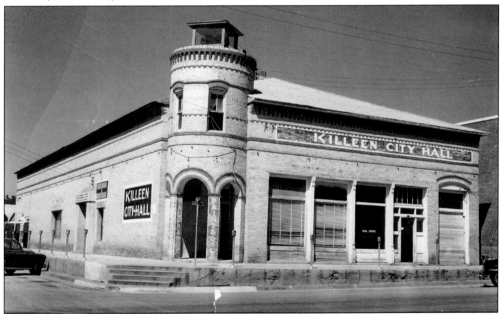

Built in 1908 as a business, this building was purchased by the Town of Killeen in 1935 for $1,750. Located at Sixth Street and Avenue C, it served as city hall and the police station until a new city hall was built in 1965. In its early years, the fire department also used the Sixth Street facilities. This 1950s photograph shows one of several refurbishing attempts to make the building more attractive.

Levi Anderson, who came to Killeen in 1884, was one of the town's earliest merchants—first in lumber and hardware and later in general merchandise. His limestone building, at Avenue D and Gray Street, still bears its 1899 completion date. In 1904, he became associated with the newly established Killeen Independent Telephone Company. Anderson was a member of the Knights of Pythias and of Woodmen of the World, in addition to being a staunch Baptist.

Visits by traveling carnivals were welcome in early Killeen. These young ladies, attending a carnival on September 26, 1906, pose in an automobile cutout. From left to right are Willie Gallaway, Isa Hoover, Essie Chanslor, Nettie McCorkle, Vinnie McCorcle, Sallie Hoover, and Franke Chanslor.

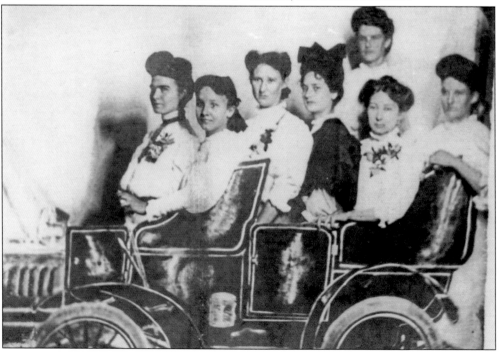

The Richard Moses Cole family gathered for this portrait in front of their home in the 1880s. From left to right are (in the yard) Ollie, baby Varina (in the carriage), Etta, Kitty, Sara, Will, Richard M. "Uncle Dick," and Omar Cole; (on the porch) Sallie Adeline Blackwell "Grannie" Maples and Edgar, Alice, and Ophelia Cole. The house was replaced around 1900.

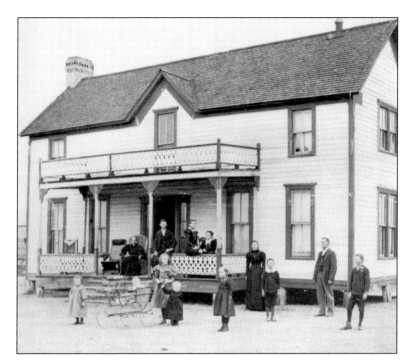

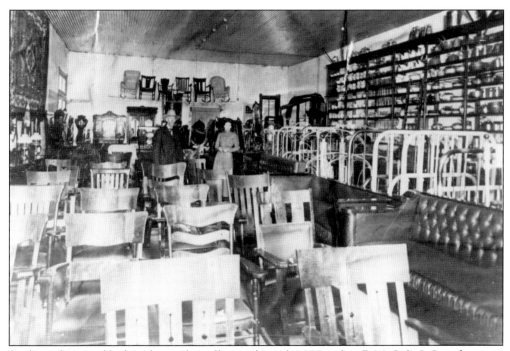

Rocking chairs and bedsteads were big sellers in the early 1900s, when R.M. Cole & Sons furniture store was in operation on Sixth Street in downtown Killeen. On the wall to the right, numerous pots and pans await customers. "Uncle Dick" Cole also provided undertaking services.

The family of R.T. "Top" Polk, Killeen's first mayor, occupied this home in 1886. The home, known as the "Old Meschalk House," was located at the corner of Rancier Avenue and Sixth Street. According to writer Gra'Delle Duncan, young Top witnessed outlaws Jesse James, Cole Younger, and their brothers seeking lodging at the Polk home in neighboring Palo Alto, an incident that was later confirmed by a reformed Younger.

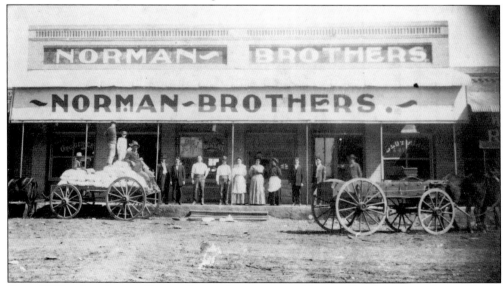

One of Killeen's earliest and longest-lasting businesses was Norman Brothers general store. Begun in 1896 by three Norman brothers—Jim, Henderson, and Ed (later joined by J.F.)—the business was strictly a family affair. It was located on the north side of Avenue D, between Fourth and Sixth Streets, and continued operating until 1947.

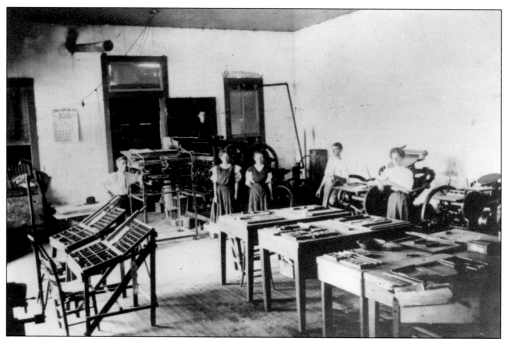

Killeen Herald workers pause from their labors in the composing and printing areas in this photograph, taken about 1906. Pictured are, from left to right, owner W.T. Carter (beside the folding machine), pressman Charlie Craddock (in the back of the room), Carter's sisters Ada Adams and Callie Carter (in front of the press), Port McCorcle, and Hettie McCorcle.

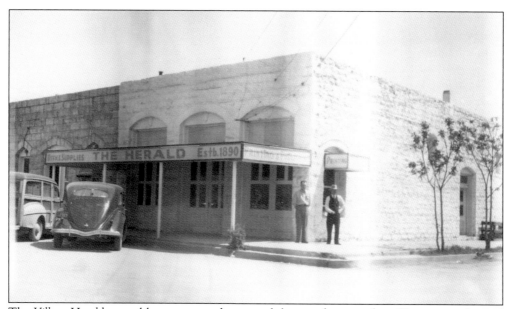

The *Killeen Herald*, a weekly newspaper that served the area for more than 50 years, was located on the southwest corner of Avenue C and Sixth Street. The newspaper's publisher, W.T. Carter (right), is pictured along with his son Bill, who operated Carter Printing Company after the *Herald* became a daily.

The late Ellis Stirling, son of Ed and Myrtice Stirling, donated this photograph labeled "Killeen Band" to the Killeen Area Heritage Association. Young Stirling graduated from Killeen High School, served in the military during World War II, and worked at Fort Hood for many years. Brothers Ed and Will Stirling, along with Dillard Shofner, operated the Shofner-Stirling general store on Avenue D, a one-story structure adjoining the present-day Municipal Court Building.

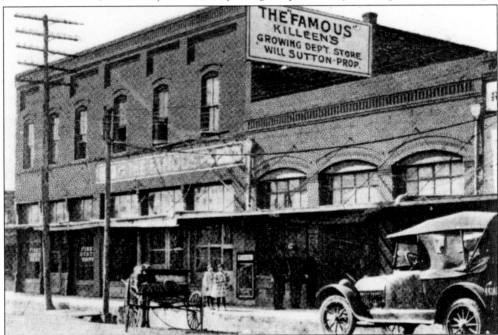

The sign advertises it as "The "Famous" Killeen's Growing Dept. Store, Will Sutton-Prop." For many years, it was known simply as "the Will Sutton store." This 1920 picture appeared on a postcard with an advertisement that "50 bolts of extra heavy outing, all colors (formerly priced at 45 cents a yard) goes on sale Dec. 15 at 17 cents a yard." The store featured entrances on both Avenue D and Fourth Street.

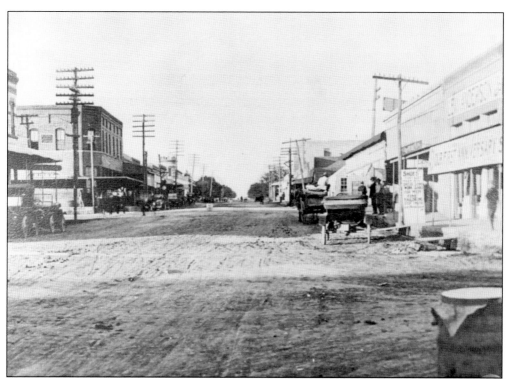

In the early 1900s, Killeen's streets were either dreadfully muddy or dry and rutted. The picture above was made on Avenue D, just east of the Sixth Street intersection, looking north. Seen below is Killeen's business section, which finally became paved during the Great Depression in the 1930s. The Works Projects Administration (WPA) helped with the pavement project as well as residential street graveling. Late congressman Robert "Bob" Poage worked with Killeen businessman and postmaster Earl Massey to obtain WPA assistance, part of the federal government's New Deal, a job creation program initiated when the nation suffered 25 percent unemployment.

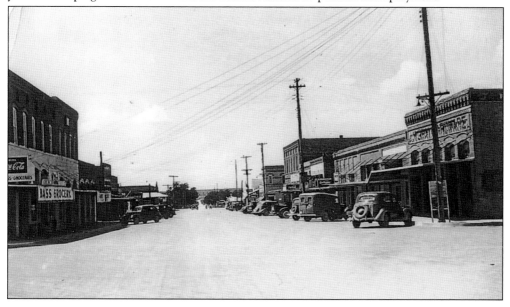

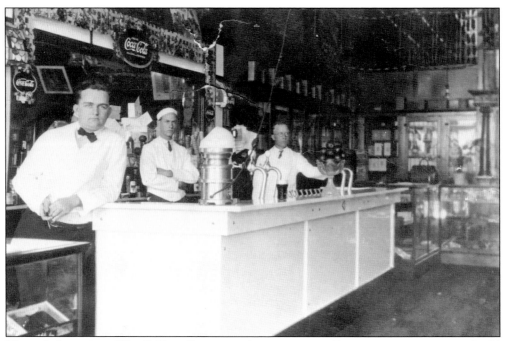

The soda fountain at Wood's Drug Store was a big attraction, offering ice-cream cones and cold drinks, along with other delicacies. Shown behind the counter in this 1925 photograph are, from left to right, Clarence Wood, Guy Evans Sr., and Weaver Jackson.

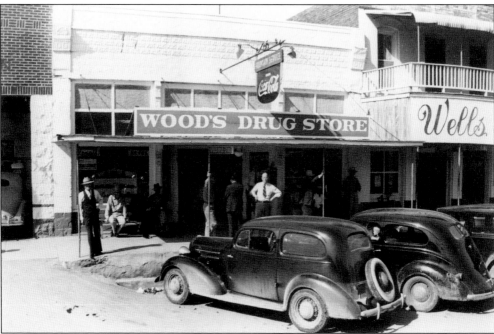

Wood's Drug Store was founded in the early 1900s by Dr. D.L. Wood (one of Killeen's earliest physicians) on the north side of Avenue D between Sixth and Fourth Streets. In addition to dispensing medicines, it served as a favorite meeting spot for Killeen's townspeople. Wells Meat Market was located next door.

Fashionable Killeen High School students pose at their "modern" brick school, which opened in 1924. All dressed up for church, graduation, or both are Virginia Bess Smith and Cecil Carter. Their school, which replaced the stately 1902–1903 school after it burned, is known as Avenue D School. Today, it serves as Killeen's city hall. Some former students preferred the new building, they recall, because it featured indoor plumbing.

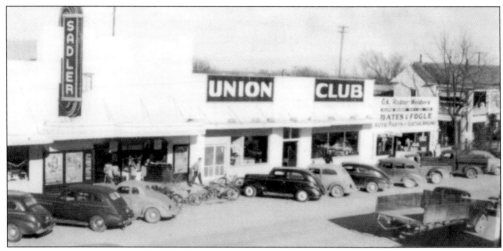

The Sadler Theater, on the north side of Avenue D between Sixth and Eighth Streets, was a popular gathering spot in the early 1940s. According to this 1944 picture, *Tall in the Saddle* was the featured attraction with *Girl of the Limberlost* on tap. Visible to the right are the Union Club, Bates & Fogle Auto Parts, and the Killeen Hotel.

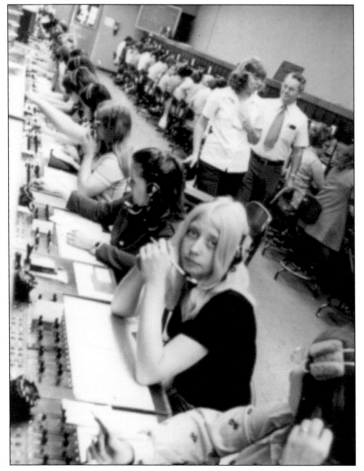

Telephone operators working for Mid-Texas Telephone Company in Killeen stayed extremely busy trying to keep up with a growing list of subscribers. W.S. Bain of San Antonio purchased the longtime phone company, Rural Telephone System, in the 1930s. It evolved into Mid-Texas in the late 1940s.

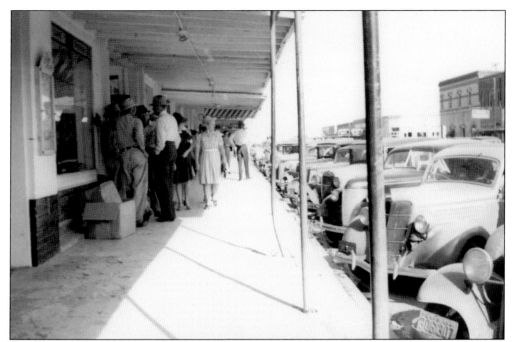

Killeen's downtown sidewalks were filled with shoppers, especially before the 1950s. Here, cars lined up on Avenue D indicate a good day for merchants. Women wore hats and often gloves, the usual attire for "going to town" in the 1940s. On Saturdays, teenagers often joined the scene, rehashing Friday night's football game, making plans for Saturday night, or simply hanging out.

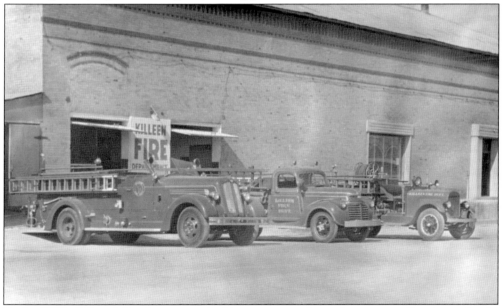

By the 1950s, Killeen's fire department had begun to grow in equipment as well as in service. In front of the department, located behind city hall at Gray Street and Avenue C, are, from left to right, a 1951 model Seagraves 750-gallon-per-minute pumper, a 1941 GMC 500-gallon-per-minute pumper, and a 1928 Reo 350-gallon-per-minute pumper. In 1952, the department finally acquired its own building on Avenue D at a cost of $25,000.

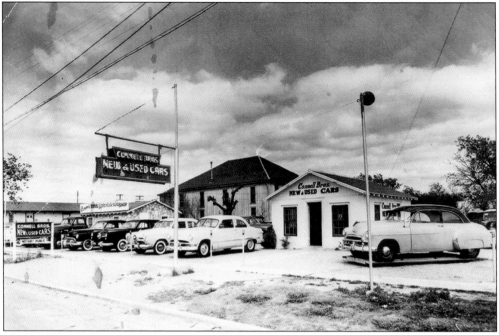

The name Connell quickly became associated with the automobile business after Ted C. Connell chose Killeen for his home after World War II. He arrived with $1,800 in his pocket, which he used to establish a used-car lot that would evolve into Connell Chevrolet. It was just one of many businesses owned by the former Army sergeant and civic leader known locally, statewide, and nationally.

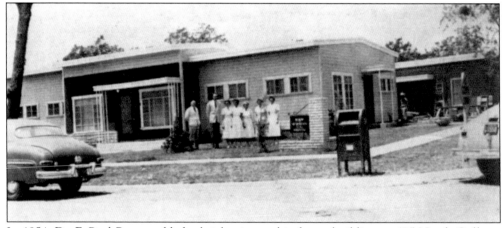

In 1954, Dr. F. Paul Burow added a brick wing to his frame building at 415 North College, establishing Killeen's first hospital and providing beds for a few patients. Dr. Burow (far left) and his partner, Dr. Marcus L. McRoberts (second from left), stand in front of the clinic and hospital, along with members of their staff. In 2013, the remodeled building serves as the Bigham Unit of the Clements Boys and Girls Club.

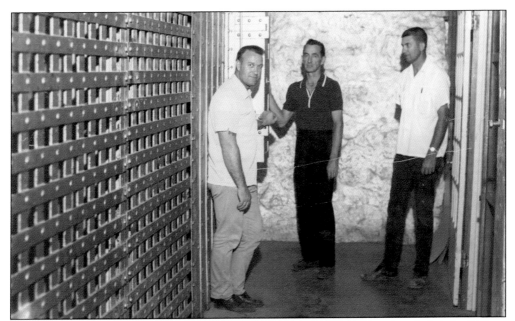

Killeen's second city hall, at Second and Avenue C, opened in 1965 and included the Killeen Police Department and a municipal jail. Police chief B.W. "Buster" Adams (center) shows off the facilities with the assistance of two of his officers—Don Cannon (left), who later became chief, and Leon Phillips (right).

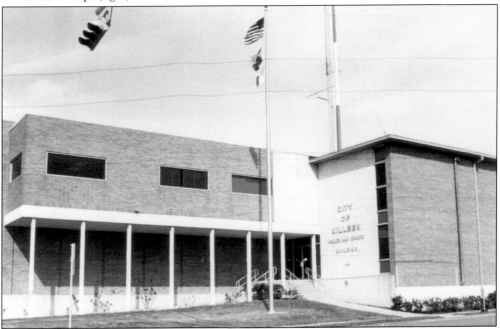

Killeen's 1908-built city hall on Gray Street (formerly Sixth Street) became overcrowded and obsolete after more than a half century of use. City leaders built this facility at Second Street and Avenue C, occupying the building in May 1965. The new structure housed the administrative offices, municipal court, police department, and jail. Today, it serves as administrative headquarters for the Killeen Police Department and accommodates a small police force.

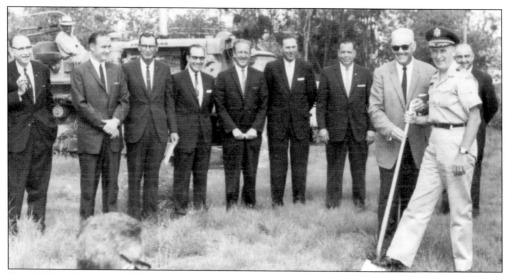

At the July 1961 ground breaking for Killeen's first major hotel, the Cowhouse, Mayor John C. Odom and Maj. Gen. W.H.S. Wright (Fort Hood commander) took turns with the shovel. Also present were hotel board officers and directors. From left to right are Andy Craig; Ted C. Connell; R.C. Adams Jr.; F.W. Baumann Jr.; Jack Duncan; A.H. Curtis; Paul Goode; and Dan Manfull, chamber of commerce manager.

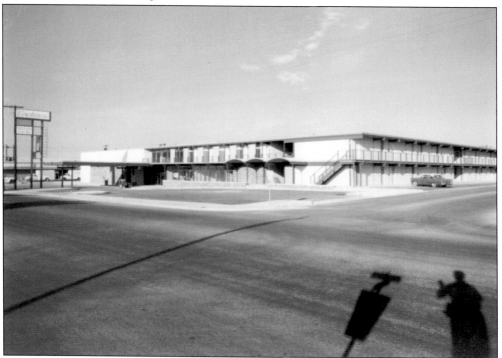

The Cowhouse Hotel, named for a creek on the Fort Hood reservation, opened its doors in August 1962, giving Killeen first-class accommodations. The community-enterprise hotel, valued at nearly $1 million, was built after an intensive campaign in which Killeen residents and businesses purchased hotel stock. The Cowhouse, later sold to a private company, had 80 rooms, a banquet hall, meeting rooms, a restaurant, a club, and a pool.

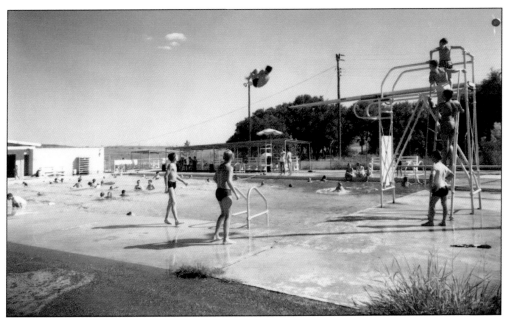

Many Killeen youngsters learned to swim at the Conder Park pool, the city's first concrete swimming pool, which opened in May 1954. The facility closed in the early 1990s, when necessary renovations were deemed too expensive. The city now has other pools and water parks to serve the public.

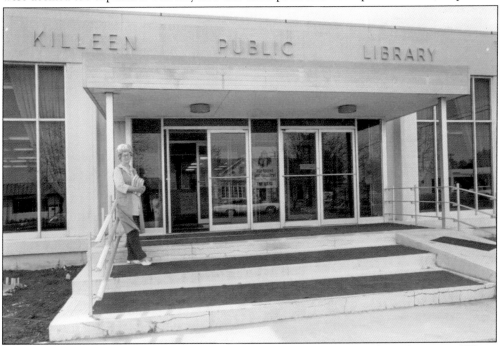

Helen Hinkel, pictured above in 1967, was Killeen's first city librarian. Library history in Killeen dates to about 1933, when the Wednesday Review Club organized the first public library in their clubhouse at the corner of Green and Second Streets. Members donated books, and the library was open once a week. Modern library service was begun in 1959 by the Kiwanis Club in a storefront with about 10,000 volumes. The current downtown library opened on November 20, 1966.

In 1966, the privately operated Skylark Field became Killeen Municipal Airport, giving a boost to local aviation. Traffic, however, was limited to small craft, like the Cessna 170 and a Beechcraft model accommodating five passengers plus one pilot. Entering the passenger compartment sometimes involved climbing onto a wing or using a small step stool. This new terminal opened in 1979, and this Rio Airways Beechcraft was the first passenger plane to depart.

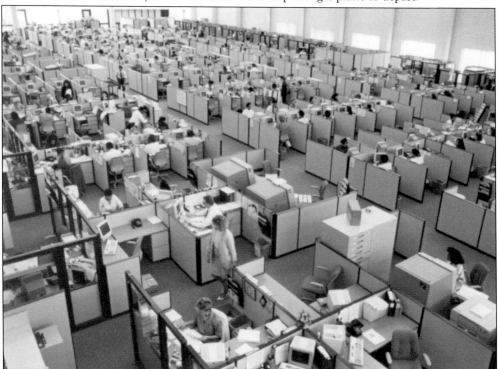

Sallie Mae, a student loan marketing association and longtime major employer in Killeen, opened in the Killeen Business Park in 1994. Operations began in a rented building, which the company bought and used before erecting a new structure nearby. This photograph shows the workplaces provided after the new building was expanded in 1995. Since 2010, the building has been headquarters for Aegis Communications Group, a global outsourcing services company.

Four

EDUCATION
KILLEEN PRIZES SCHOOLS,
ONE ROOM TO MAJOR UNIVERSITY

Overcoming many obstacles, including storms, fires, and reluctant state officials, Killeen has developed an educational system that permits students to advance from prekindergarten to graduate status.

Killeen's first school, located at what is now the intersection of Fourth Street and Avenue B, was a 20-by-40-foot, one-room facility with crude seats and no desks. Teachers were W.E. Hudson, superintendent, and Willie Davis, assistant superintendent. A small tuition was charged.

In 1884, a free public school opened on the south side of Avenue D, near Second Street. It was destroyed by a tornado in 1887. Replacing a second frame building, Killeen's first brick structure was constructed in 1902–1903, but on March 15, 1923, it was destroyed by fire. It was replaced by Avenue D School, today's Killeen City Hall. Avenue D served as Killeen's only school until Camp Hood came in 1942, bringing a rapid growth in Killeen's population.

Student growth never wavered after that. By 2012, Killeen Independent School District had 32 elementary schools, 13 middle schools, and 4 high schools as well as several specialty campuses.

The need for higher-education opportunities for the area resulted in the creation of a community college, and on September 19, 1967, Central Texas College (CTC) opened its doors with an enrollment of 2,081. Immediately successful, CTC expanded services and designated itself as the American Educational Complex. Under that umbrella, the college established American Technological University.

Texas Education Agency, guarding against mixing state funds with private university funds, ordered that ATU be made a separate entity. Thus, the University of Central Texas, an upper-level, private university, was formed. A Texas Higher Education Coordinating Board plan allowed the university to be state supported under Tarleton State University until mandated criteria could be met. This gave the area Texas A&M University-Central Texas (TAMUCT), which opened in 2009 in leased space. In 2012, the university opened the first building on its 662-acre campus on State Highway 195.

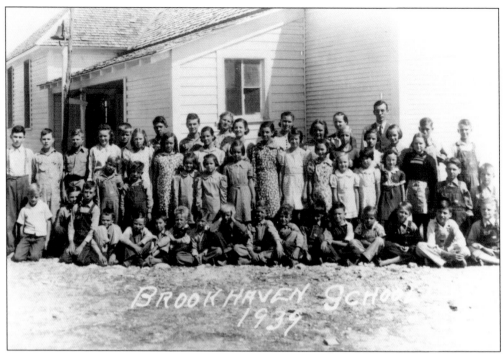

Brookhaven School escaped the first federal government land acquisition for Camp Hood; it was later sold by Belton school trustees as part of Fort Hood expansion and the building of Belton Dam. In the 1930s, upper-grade students went to school in Killeen; after 1947, they were transported to Belton. In this 1939 photograph, Brookhaven students stand beside one of several frame buildings the school used through the years.

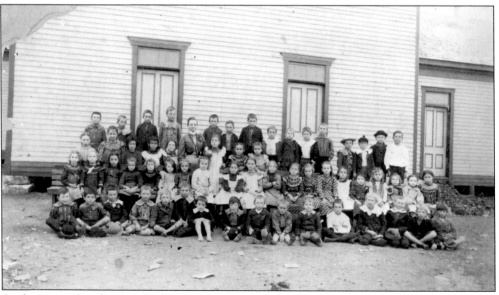

Students pose beside one of Killeen's first schools, a frame building located on Avenue D, near Second Street. The school was built before the turn of the 20th century. One of Killeen's early frame schools (the second built), it was destroyed by a tornado on June 21, 1887.

Killeen's first brick school building, which housed all grades, was constructed between 1902 and 1903. The impressive structure was the pride of Killeen. The building was destroyed by fire on March 15, 1923, and was replaced by Avenue D School, which now serves as Killeen City Hall.

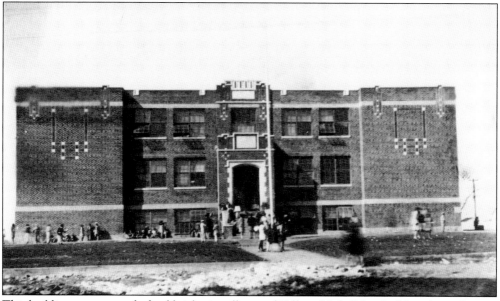

This building, constructed of red bricks, is still named Killeen High School, although it is known today as Avenue D School. Located on College Street at the point where it meets Avenue D, it had space for all grades in the school system for more than 40 years. Separate entrances designated for boys (on the north side) and girls (on the south side) reflect a bygone era. The building is now used as Killeen's city hall.

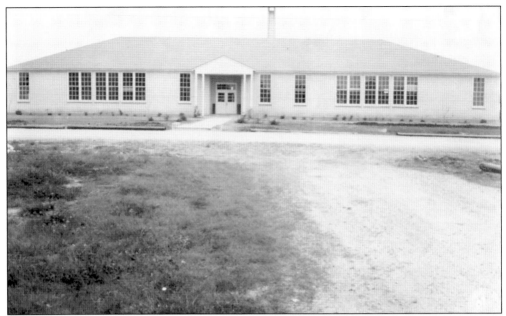

In 1944, school officials built a new facility at Tenth Street and Rancier Avenue to house two sections each of sixth, seventh, and eighth grades. Earlier, Lee Peebles, superintendent since 1935, had ordered half-day classes at Avenue D School, where all grades were previously housed. This new school was eventually enlarged, becoming Killeen's first stand-alone high school. It later became a junior high school, a middle school, and a support center.

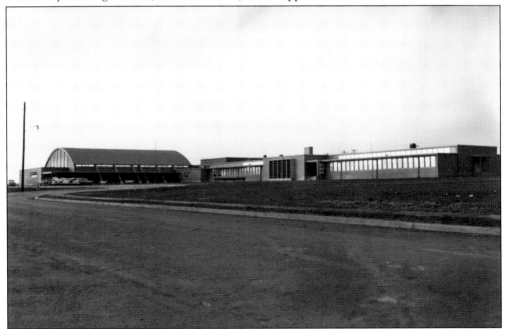

Students enjoyed a new, modern facility in 1955 when Killeen High School left its Rancier and Tenth address for a site at Williamson and Whitlow Drives, in the northwest corner of the city. The location served until 1964, when student growth necessitated another move. By the mid-1950s, classes had spilled over into business sites across the street from the high school.

A 60-acre campus on Thirty-Eighth Street, just north of the railroad, became the home of Killeen High School in 1964. Despite being expanded over the next 14 years, the school—photographed here by Todd Martin for the Killeen Independent School District (KISD)—was unable to accommodate the large student population. In the late 1970s, the KISD Board of Trustees took a big step, opting to make KISD a district with two high schools. C.E. Ellison High School opened in 1978.

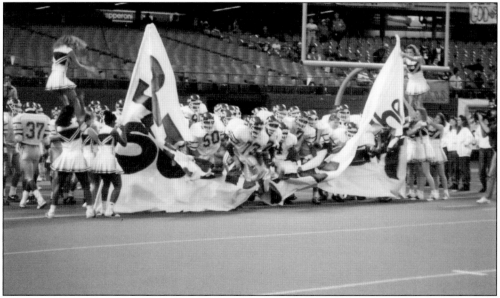

Killeen High School's Kangaroos break through a cheerleader-held banner on their way to a state championship in football. Killeen defeated Sugar Land Dulles 14-10 for the Class 5A, Division 1 title. KISD's Bob Massey caught this dramatic moment on December 14, 1991, at the Astrodome in Houston.

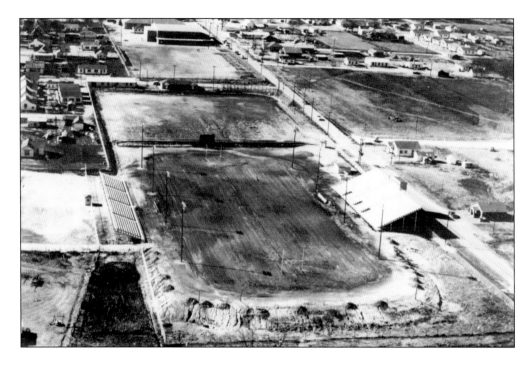

Killeen High School acquired a new football field in the late 1940s, vacating the old field, which was a short distance west from the new location. Both fields were on Rancier Avenue, behind the school. The photograph above was taken looking west on Rancier Avenue. Killeen's current football field (below) was built behind the new Killeen High School, which opened in 1964. This aerial photograph was made looking to the west.

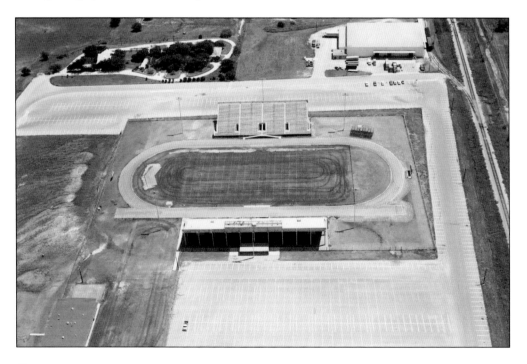

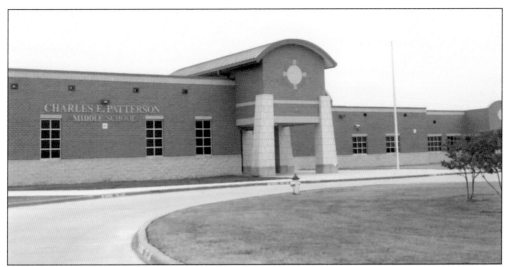

One of Killeen's present-day newer schools, Charles E. Patterson Middle School (on West Trimmier Road), is named for a popular former Killeen Independent School District superintendent. A Hamilton native, Dr. Patterson served as superintendent from 1988 until 2004 and was named Superintendent of the Year by the Texas Association of School Boards in 1995. Prior to becoming superintendent, Patterson had held several teaching and administrative positions in the district.

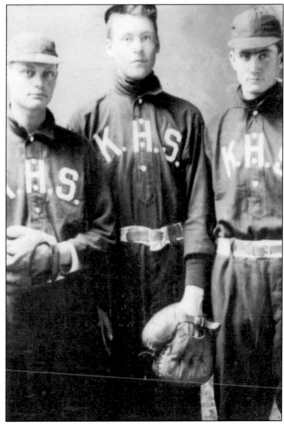

Baseball was early Killeen's most popular sport. These three Killeen High School players, pictured around 1912, are, from left to right, Grady Collier, Mofford Duncan, and Spencer Young. Three decades later, Kyle Hilliard also played for the team. In 1942, Hilliard took the bus to Austin and walked to the home of University of Texas coach Billy Disch. Disch welcomed him, got him a job, and eventually secured him scholarship. Hilliard played for two years, served in World War II, and finished college in 1949.

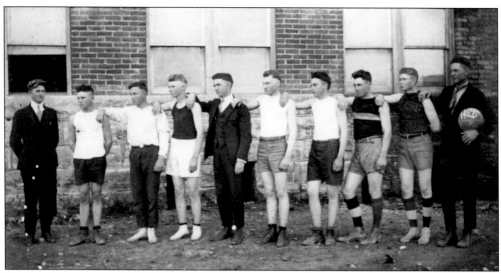

Basketball uniforms have changed dramatically since this photograph was taken at Killeen High School in 1920. For many years, baseball was the most popular sport in town, but basketball and football came along and eventually became dominant. These players' identities are lost to history, but Killeen's high school teams continue to compete successfully in interscholastic contests.

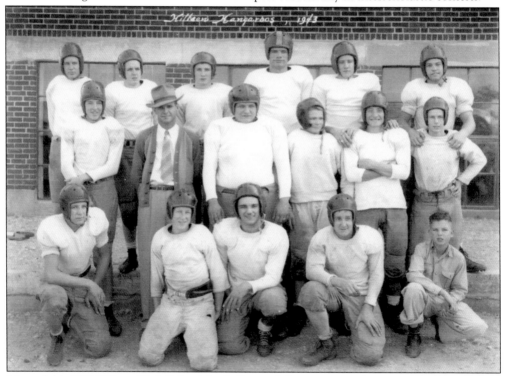

Most of this 1943 Killeen High School football team left to go into military service. Pictured are, from left to right, (first row) Joe Wade Stansell, Benny Bay, Howard Henderson, Bert Norman, and Bill Sadler (team manager); (second row) Derwood Berry, Leo Buckley (coach), ? Jernigan, D.L. Saegert, Earl Baker, and Wayne Arnold; (third row) Bill Hickman, Curtis Bay, Edwin Baker, Jake Locklear, Clifford Dockery, and Gayle Toliver.

Labeled as Killeen High School's first pep squad, these students sport uniforms featuring a big K. This undated photograph came from a collection of Ruby (Mrs. Hulon) Richardson, a member of one of Killeen's early families.

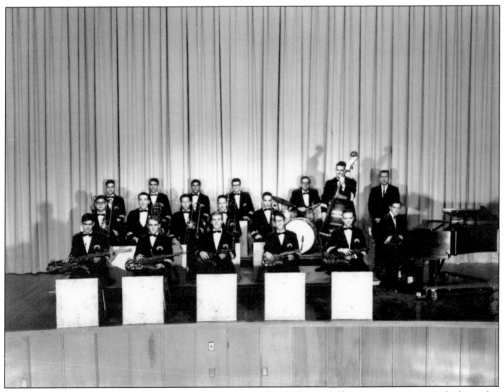

Killeen High School developed many musicians through its different programs, including the Killeen High School Stage Band, shown in this photograph from the 1970s. Students auditioned for limited places in the band, which performed for various school and community functions.

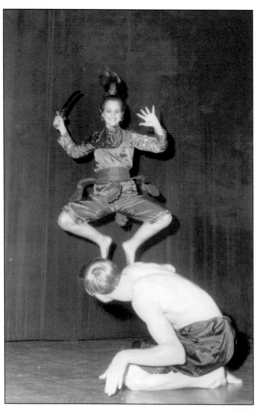

Even before Vive Les Arts, a local, full-time communtity theater/arts organization, and Killeen's community theater came into being, residents enjoyed musical productions for many years, thanks to the professionalism of Killeen High School's drama teacher, Ron Hannemann. Hannemann developed high school talent to the extent they could handle Broadway-type musicals, such as *The King and I*, a scene from which is pictured here.

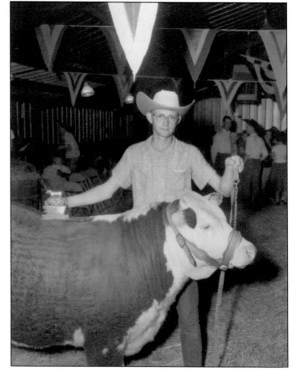

The annual 4H-FFA Junior Livestock Show recalls Killeen's history as an agricultural center. In 1957, Killeen High School junior Jack Husung exhibited the grand champion steer. Husung, who has spent more than 40 years in the ministry, continues preaching and showing championship cattle, nowadays at prestigious national shows. After "retiring" from Killeen's Skyline Baptist Church, he became pastor of Cedar Valley Baptist Church.

Killeen's second high school, named for former superintendent Dr. C.E. Ellison, opened in the fall of 1978, relieving a greatly overcrowded Killeen High School. Ground breaking for the new school, located at Trimmier Road and Elms Road, was held in 1976. Participants included, from left to right, Nell Franz (KISD board member), Dr. Clarence Ham (superintendent), C.W. "Bud" Duncan (board president), and John W. Driver (future principal of Ellison High School).

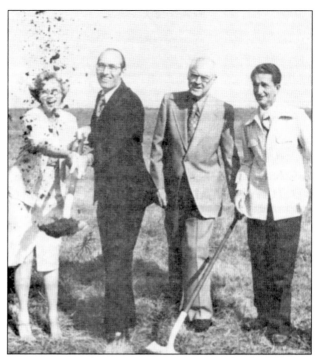

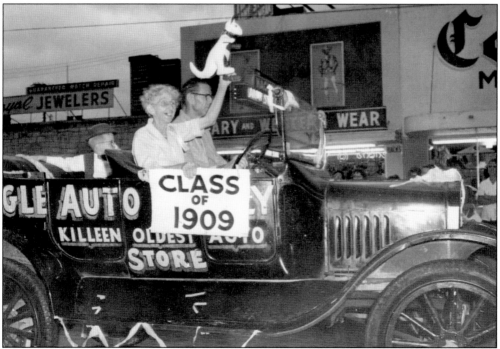

Eugenia Fitzpatrick, known as "Miss Genie," represents the Killeen High School class of 1909 and the school's kangaroo mascot while riding in a Killeen parade. Miss Genie was a Killeen Independent School District librarian for more than 40 years. She was the daughter of Dr. J.B. Fitzpatrick, Killeen's second physician, and Emma Richardson Fitzpatrick, the adopted daughter of Killeen's first hotel owners, John and Mary Richardson.

"Miss Myrtle" was graduated from Killeen High School in 1912 and had already occasionally served as substitute teacher for $1 per day. Beginning her career in rural schools, Myrtle Irene Smith officially retired in 1966 after 52 years of teaching in all grade levels but continued to serve as substitute teacher for many years. She died in 1994 at the age of 100.

Catching up at the 2012 Avenue D School reunion are, from left to right, Sue Williamson Hallmark, LaVerne Schulz Goins Flentge, and Ruth Hennersdorf Straus. The reunion, held every other year since the mid-1970s, is well attended. Avenue D was the second brick school in Killeen, replacing an elegant Richardson-Romanesque building that had burned on March 15, 1923.

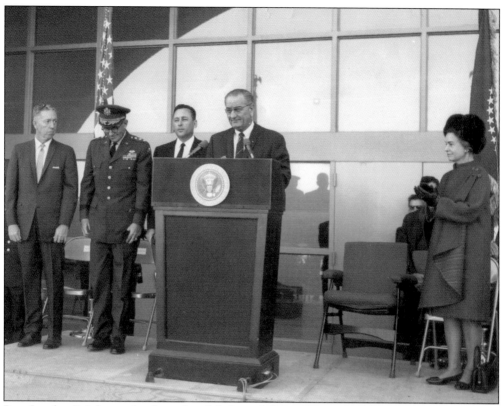

Pres. Lyndon B. Johnson (at the podium) dedicated Central Texas College on December 12, 1967. Behind the president are, from left to right, William S. "Bill" Bigham (president of the college board), Lt. Gen. George R. Mather (Fort Hood commander), Dr. Luis M. Morton Jr. (college president), and Oveta Culp Hobby, a Killeen native who was the first director of the Women's Army Corps and the first secretary of the Department of Health, Education, and Welfare, for whom the CTC library was named.

Members of the first board of trustees for Central Texas College pose for their formal portrait. They are, from left to right, (first row) Marvin Mickan (Copperas Cove), Guinn Fergus (Killeen), Maureen Frederick (Copperas Cove), and J.A. "Att" Darossett (Copperas Cove); (second row), Birt Wilkerson (Nolanville), William S. "Bill" Bigham (Killeen), Dr. Luis Morton Jr. (CTC president), and Dr. W.A. "Bill" Roach (Killeen).

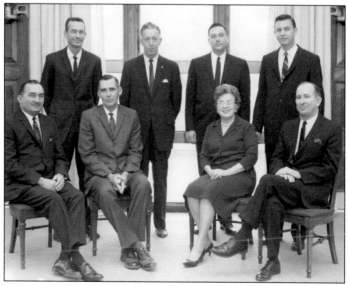

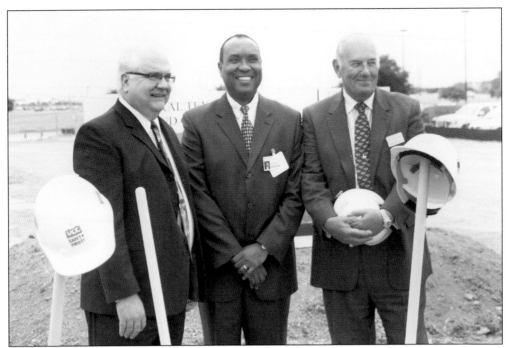

Ground was broken in July 2009 at Central Texas College for a new 85,000-square-foot nursing building to serve CTC, Texas A&M University-Central Texas, and Metroplex Hospital. Participating in the event were Dr. Garry Ross (left, president of TAMUCT), Carlyle Walton (center, administrator of Metroplex Hospital), and Dr. James Anderson (chancellor of CTC).

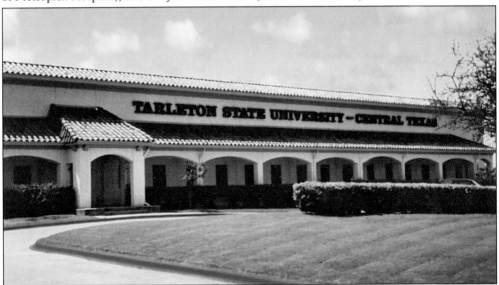

Tarleton State University-Central Texas, a part of the Texas A&M University system, provided area students a chance to receive baccalaureate and graduate degrees in a state-supported university. The Texas Higher Education Coordinating Board approved a plan whereby Tarleton would operate a university in Killeen until the school could meet specified enrollment numbers to become a stand-alone university. Tarleton remained until Texas A&M University-Central Texas opened in 2009.

Five

GLOBAL KILLEEN
FORT HOOD BRINGS
DIVERSITY AND CHANGE

September 18, 1942, brought seismic change to Killeen. That was the day that Camp Hood opened next door to a small town of just over 1,200, completely changing the local economy and creating a pattern of diversity that would eventually make Killeen a cosmopolitan city.

More than 30,000 construction workers had been working since spring 1942, urgently converting agricultural land into a military post for training and equipping American soldiers to meet the challenge of German tanks in Europe and North Africa.

In order to build the camp, named for Confederate general John Bell Hood, the Army displaced some 300 families, most of whom gave up homesteads reluctantly, but with remarkably patriotic spirit, for what most considered less-than-adequate compensation.

For Killeen itself, Camp Hood's opening began a growth period that dramatically increased in April 1950, when Camp Hood was declared a permanent Army post and renamed Fort Hood. With more families joining soldiers, Killeen's population began a rapid upsurge—from 7,045 in 1950 to 23,377 in 1960. By 2010, the population stood at 127,921.

Killeen had supported the war effort, too, sending many of its young men into battle. World War II veterans estimate the number of Killeen-area residents who served at 180.

Fort Hood became a catalyst for diversity. For its first 60 years, Killeen had been a totally white community, with no blacks permitted in town after sunset. Many black soldiers came to Camp Hood during the early days, but only after Pres. Harry S. Truman integrated the military in 1948 did black soldiers began appearing in Killeen. In 1956, Killeen became one of the first towns—if not the first—in Texas to begin integrating its schools.

Killeen also experienced an influx of other ethnic groups, particularly among soldiers' wives at first. The new arrivals included Asians, Europeans, and Hispanics, plus many from the South Pacific.

Today, Killeen is, percentage-wise, one of the most diverse cities in the nation. This diversity manifests itself in schools, government, houses of worship, and the business community.

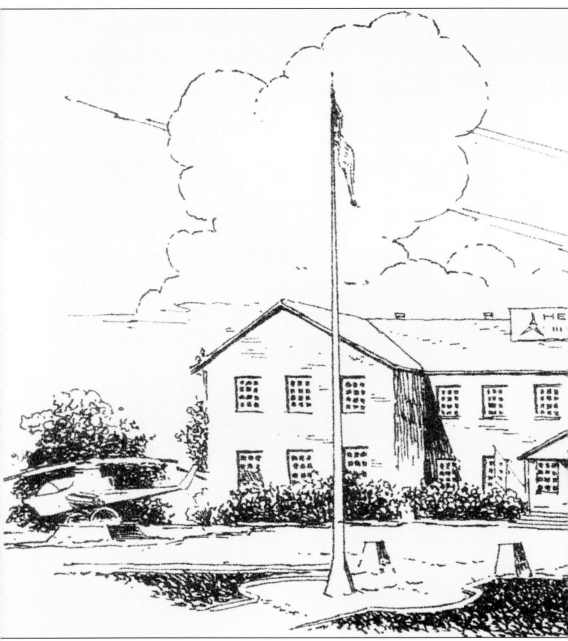

This drawing by artist John Carter depicts Camp Hood's headquarters building, a structure that

remained throughout the 20th century.

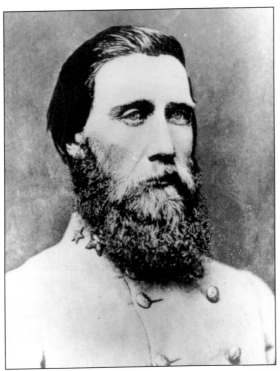

Camp Hood was named for Confederate general John Bell Hood, a Kentucky native who, for about six months, commanded Hood's Texas Brigade (the group would retain the name for the duration of the Civil War). The organization was comprised of three Texas infantry regiments and also included soldiers from Arkansas, Georgia, and South Carolina. Known for his personal bravery, Hood lost a leg at Chickamauga and the use of his arm at Gettysburg. He died during a yellow fever epidemic in New Orleans in 1879.

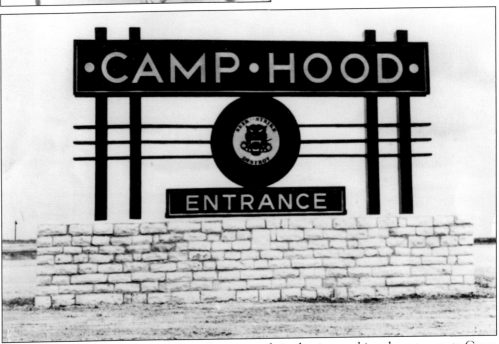

A tiger crunching a German tank figured prominently in the sign marking the entrance to Camp Hood. Camp Hood's mission was to train and equip soldiers to wipe out Germany's destructive tanks. One famed Army leader at Camp Hood was George S. Patton Jr., Second Armored Division commander and later Third Army commander during World War II. His son, Maj. Gen. George Smith Patton, later commanded the Second Armored Division at Fort Hood.

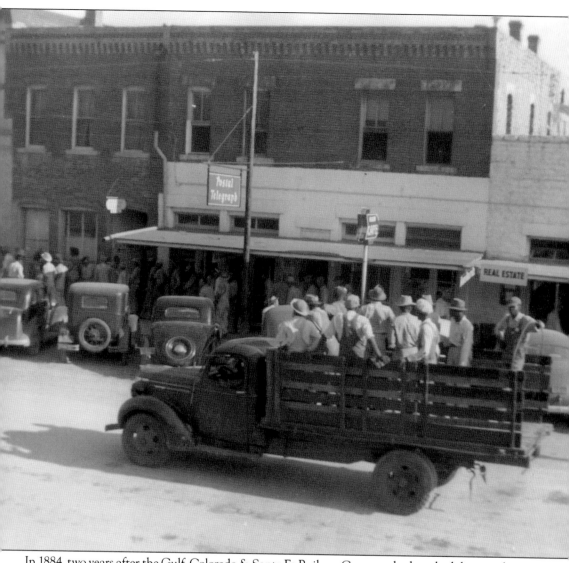

In 1884, two years after the Gulf, Colorado & Santa Fe Railway Company had reached the area that became Killeen, the new town had a population of 350. Twelve years later in 1896, the population reached around 700, many of the new residents arriving from nearby communities like Palo Alto, Sugar Loaf, Youngsport, Brookhaven, and Maxdale. Then for the decades between 1900 and 1940, Killeen's population hovered around 1,200—until the US government and the US Army decided to build Camp Hood, packing Killeen with hundreds of temporary construction workers and a few families of military personnel assigned to the new tank destroyer training center. In this photograph, Camp Hood construction workers come to Avenue D to cash their checks on payday. Townsfolk rented spare bedrooms, attics, barns, chicken houses, and any other accommodations they could find for some 30,000 workers, some of whom slept in their vehicles and tents during the height of the camp's construction, from April to September 1942.

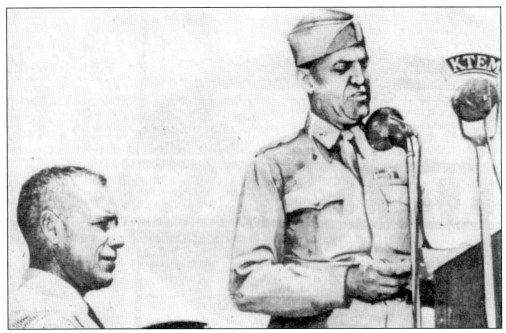

Some 25,000 people were on hand when Camp Hood was officially opened on September 18, 1942. At the old-fashioned microphone is Maj. Gen. A.D. Bruce, first post commander. Seated at left is R.P. Patterson, undersecretary of war, who was the main speaker at the opening event. Also in attendance was retired colonel John Bell Hood, grandson of Confederate general John Bell Hood, for whom the new post was named.

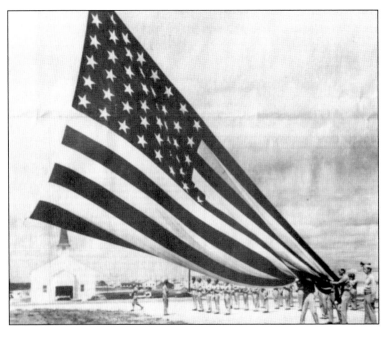

A 20-by-38-foot American flag was unfurled on September 18, 1942, marking the opening of Camp Hood. Typically called a garrison flag, the flag in this photograph had only 48 stars, as Alaska and Hawaii had not yet achieved statehood. In 1950, Camp Hood was made a permanent installation and renamed Fort Hood.

Jesse O. Ellis of Maxdale inspects what was probably the first Jeep in Killeen in late 1941 or early 1942. In the Jeep is Linda Manning, granddaughter of T.H. Adams, owner of the cotton gin in the background. The photograph summarizes Killeen's history—a "tale of two cities"—the Jeep symbolizing the arrival of the military and the gin representing Killeen's former status as an agricultural center with cotton as the principal product.

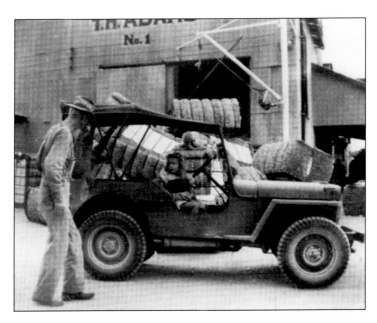

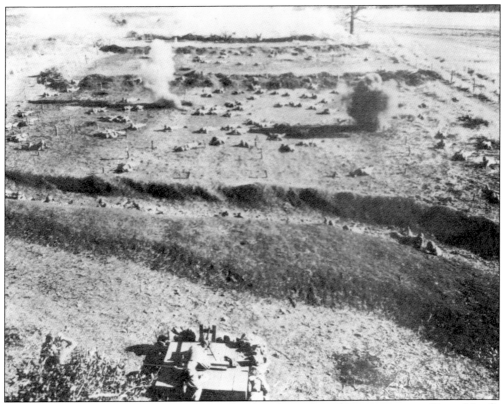

A machine gun, in the foreground, fires a few feet above the soldiers training at Camp Hood's Tank Destroyer Center, reminding them to keep their heads down. These soldiers are going through a battle indoctrination course in preparation for World War II action.

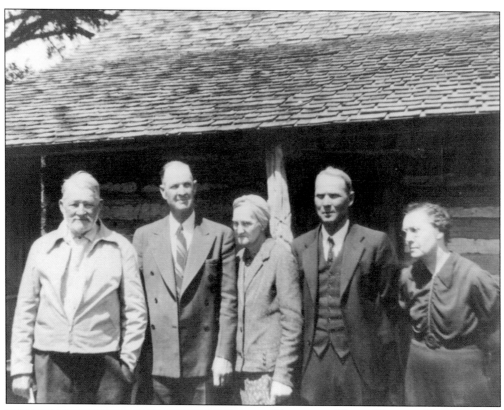

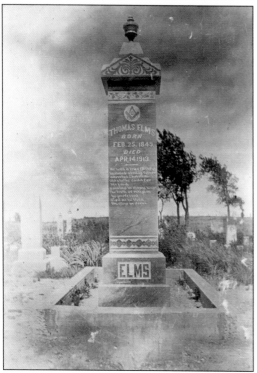

Thomas and Irena Clements Elms reared their six children in this log cabin at Sugar Loaf. Five of those children, pictured here, gathered in April 1942 for a last look at their childhood home before Camp Hood occupied the family's land. They are, from left to right, Charlie Elms, Jesse Elms, Cora Elms Young, Ernest Elms, and Izora Elms McClung. Missing is brother Edwin Meek Elms, who was not present for the occasion. The cabin did not survive. (Courtesy of Wilma McClung Smith.)

Many cemeteries were moved when Camp Hood workers began construction of the immense training area. In a 1943 newspaper article, Killeen-area residents learned that more than 700 graves had been recently relocated to area cemeteries. Sugar Loaf graves now lie in the Evergreen section of Killeen City Cemetery. This column marks the burial site of Thomas Elms, one of the Riggs children's rescuers after the Riggs Massacre of 1859. (Courtesy of Wilma McClung Smith.)

Although many homes were abandoned on farmland that became Camp Hood, Irena Clements Elms was allowed to move her Sugar Loaf home to Killeen (above). Her husband, Thomas, had died in 1913, and she had fulfilled a promise to build a larger house to replace an older cabin, according to granddaughter Wilma McClung Smith. Elms was born in 1850, and when she was told that her land would be taken, she said, "Well, I have lived through the Civil War, the Spanish-American War and the World War, and if it's necessary for this war that I move, I can do it." The Elms home (below, about 1946) stood for many years on North Eighth Street after being moved in 1942. Elms died in November 1942 and is buried beside her husband in the Evergreen section of Killeen City Cemetery. (Both, courtesy of Wilma McClung Smith.)

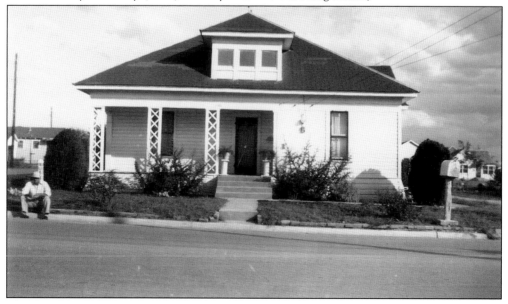

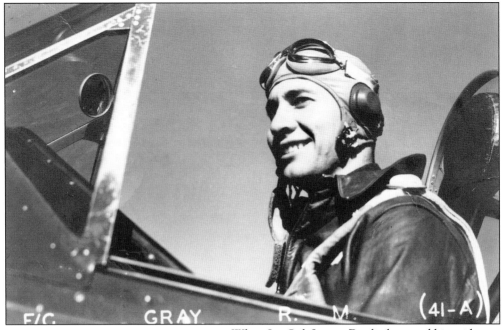

When Lt. Col. Jimmy Doolittle staged his raid on Tokyo on April 18, 1942, Killeen native 1st Lt. Robert M. "Bob" Gray piloted the third of 16 planes that set out from aircraft carrier USS *Hornet*. He had nicknamed his plane *Whiskey Pete* after the horse he formerly rode around Killeen streets. Gray, for whom Gray Street and an airfield are named, died six months later when his plane crashed near Assam, India.

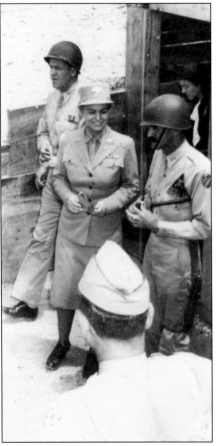

Col. Oveta Culp Hobby, a native of Killeen who became the first director of the Women's Army Corps (WAC), visits Camp Hood during World War II. She wears the WAC uniform, including the visored Hobby hat, which was named for her. Her parents, Ike and Emma Culp, were pioneer Killeen citizens.

Once Camp Hood was made a permanent installation in 1950, its name changed to Fort Hood. The post's main entrance now carries the name Bernie Beck Main Gate, honoring a Killeen banker and strong Fort Hood and Army supporter, the late Bernice M. Beck. A native of Brookhaven, Beck worked as a carpenter at Camp Hood while the new installation was under construction.

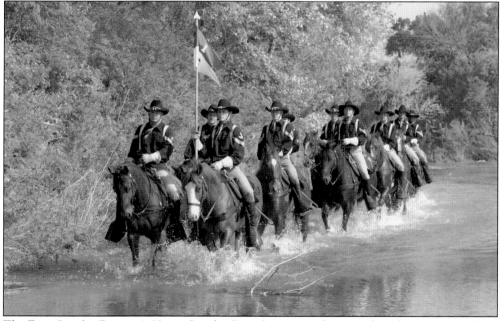

The First Cavalry Division's Horse Cavalry Detachment is a favorite of residents in the Killeen area. The unit, known as the "Horse Platoon," performs at parades, fairs, presidential inaugural parades, and the annual Fourth of July celebration at Fort Hood. Troopers must maintain regular military readiness standards in addition to carrying out typical cavalry responsibilities of the late 19th century, caring both for horses and for authentic weaponry and equipment.

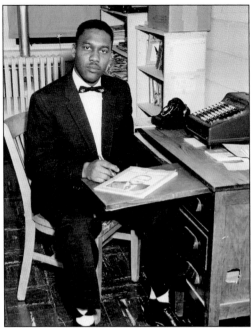

Dock Jackson made history when he became the first black principal in the Killeen Independent School District. He was chosen in 1955 to lead Marlboro Heights Elementary School, located in the Marlboro Heights Addition. The building now serves as the Dock Jackson Jr. Professional Learning Center.

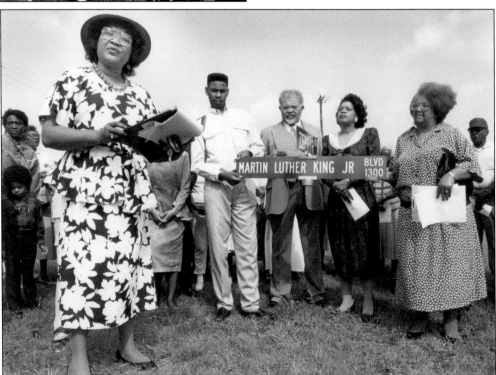

On May 12, 1990, Dr. Martin Luther King Jr. was recognized with the renaming of a section of FM 2410 in his honor. Cloerine Brewer, in the foreground, was the event speaker. Holding the street sign are, from left to right, Lamont Gilliam (son of the late Alice Gilliam, who had long sought this recognition for Dr. King), the Reverend R.A. Abercrombie (pastor of Marlboro Heights Baptist Church), Kimberly (Gilliam's daughter), and Rosa Hereford (a former city councilwoman).

Many Fort Hood soldiers took Korean brides during the Korean War era. After moving to Killeen, these women were able to invite family members to join them; thus, Koreans quickly became the largest Asian population in town. This unidentified couple, whose portrait was made from a negative by photographer Bob DeBolt, represents many of Killeen's current citizens.

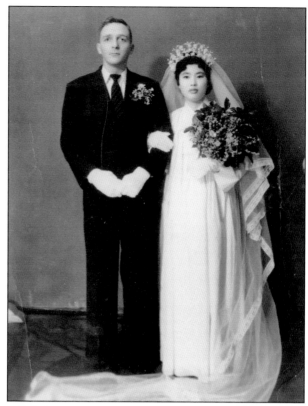

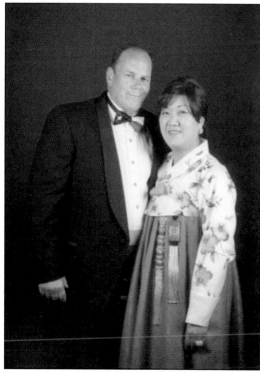

Many Fort Hood soldiers have met and married Korean brides while on US Army tours in Korea. After moving to Killeen, the wives were able to invite family members to join them; thus, Koreans quickly became the largest Asian population in town. John and Mi-Ok Doranski (left) met while John was teaching English in Seoul, Korea. They married November 1, 1986, in South Korea. In 1988, they left for a three-year tour in Germany; later they completed assignments in Kansas and Louisiana and arrived in Killeen in 1995. John, who retired from the army in July 2005 after a tour in Iraq, now works for the US Treasury Department in Waco. Mi-Ok continues to operate the *Korean Weekly* newspaper she founded in Killeen.

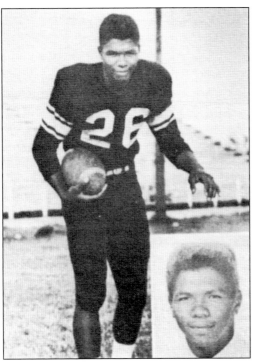

Joseph Searles III, a running back on the Killeen High School football team, is credited with helping to pave the way for the smooth integration of the Killeen school system. Young Joe also played football at Kansas State University, had a successful business career, and became the first black member of the New York Stock Exchange.

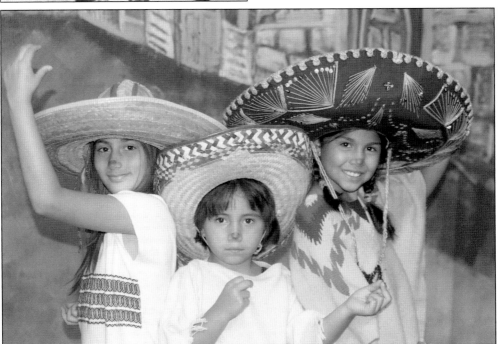

A series of festivals honors various ethnic groups throughout the year in Killeen. These young performers in sombreros are entertaining at the annual Hispanic Heritage Festival that celebrates September independence days for a number of Spanish-speaking nations, including Mexico, El Salvador, Guatemala, Chile, Honduras, Costa Rica, and Nicaragua. Other observances recognize Killeen's many culturally diverse communities.

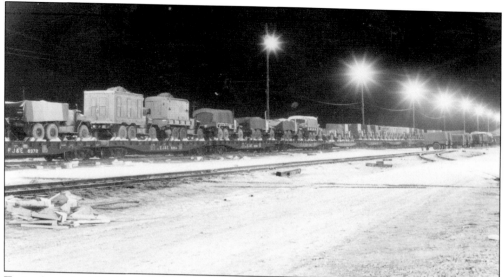

Trains loaded with wheeled vehicles headed from Fort Hood to Fort Stewart, Georgia, during the October 1962 Cuban Missile Crisis. The destination of 1st Armored Division equipment was classified, but area residents were fully aware of Fort Hood's involvement. After the discovery of Soviet nuclear-tipped missiles in Cuba, Pres. John F. Kennedy ordered a naval blockade of the island. For 13 days, the world watched as Kennedy and Nikita Khrushchev participated in tension-filled negotiations.

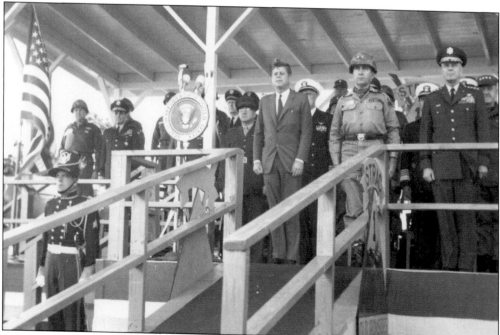

Pres. John F. Kennedy visited Fort Stewart, Georgia, after the Cuban Missile Crisis. For six weeks, the 1st Armored Division conducted live fire and amphibious exercises on the Georgia and Florida coasts. Some 19,000 troops were involved, along with 2,000 tanks and a supply of Honest John nuclear-capable missiles. On November 26, the president (center) spoke to soldiers, thanking them for their participation. At Kennedy's left is Maj. Gen. Ralph E. Haines, division commander.

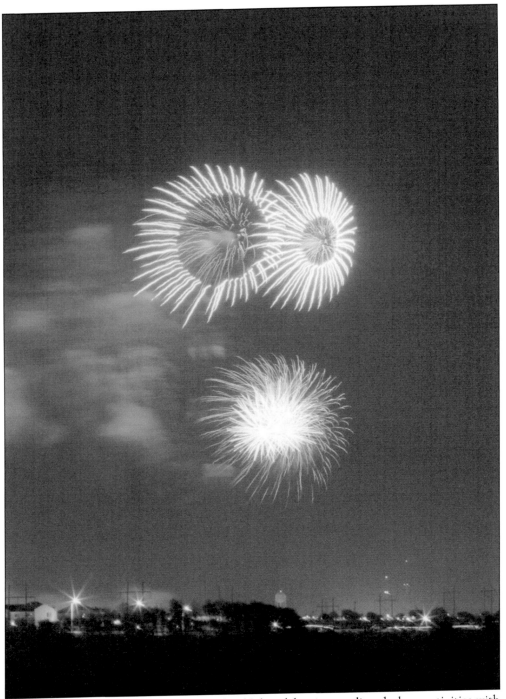

Fort Hood stages the Killeen area's Fourth of July celebration, ending daylong activities with a spectacular fireworks display. Fort Hood shares the special observance with residents of the surrounding communities.

Six

CELEBRATED RESIDENTS AND VISITORS
SPECIAL PEOPLE
BRIGHTEN KILLEEN HISTORY

From the turn of the 20th century until the beginning of World War II, Killeen was a town of just 1,200 to 1,250 residents. After the boom years of record cotton production, followed by the Great Depression, not much occurred.

Killeen, according to most definitions, could easily have been labeled stagnant. A whites-only place, Killeen had four Protestant churches (Methodist, Baptist, Church of Christ, and Primitive Baptist), plus the "German" church, south of town. In the 1940 census, Killeen recorded "no foreign born residents."

Nevertheless, Killeen produced (and later attracted) a fascinating collection of creative, productive citizens, who today are remembered with affection, honor, and more than a touch of pride. Stories about these Killeenites are of a world completely different from today's Killeen, reminding residents and visitors of a time their grandparents knew. Popular natives include Bob Gray, uninhibited protector of underdogs; Oveta Culp Hobby, first Women's Army Corps director; and James H. "Screwdriver" Arnold, a modest but highly decorated sergeant in World War II and a favorite son of Killeen.

In the decades since World War II, Killeen has attracted others who brought attention to their adopted home. Among them are Ted C. Connell, national commander of the Veterans of Foreign Wars and special aide to Lyndon B. Johnson; banker Roy J. Smith, civilian aide to the secretary of the Army who cemented Killeen's relations with neighbor Fort Hood; preeminent photographer Bob DeBolt; artist John Carter; and business leaders like Clarence Clements, who helped establish a service standard that survives today.

A sports-loving town, Killeen has nurtured numerous athletes who went on to gain national attention, including Keith Fergus, an amazing golfer even as a teenager, and Orville Moody, who won the 1969 US Open golf tournament in Houston.

Adding to the city's cultural development and ploughing tough fields as they became the first representatives of their respective ethnic groups to attain important positions in Killeen have been Willie Gibson, Joe Camacho, Timothy Hancock, Rosa Hereford, and Sara Flores. Finally, Killeen remembers its hometown personalities like Franke Chanslor; the Service Drug Gang; the city's mayors; early city marshals; early doctors, who sometimes performed emergency surgery at gunpoint; and unforgettable educators.

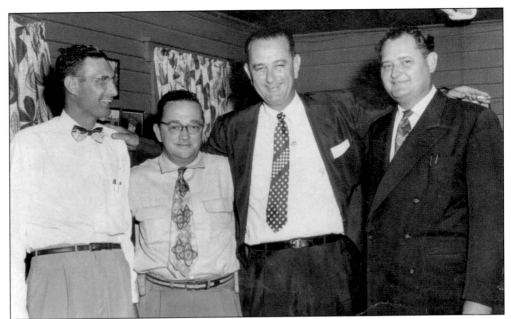

Sen. Lyndon Baines Johnson paid a visit to the Killeen Chamber of Commerce in 1953 while seeking reelection. Pictured are, from left to right, R.C. Adams Jr. (chamber president), Thomas Howell Norman (mayor of Killeen), Johnson, and Ray Baca (Killeen city manager). As president, Johnson returned to Killeen in 1967 to dedicate Central Texas College.

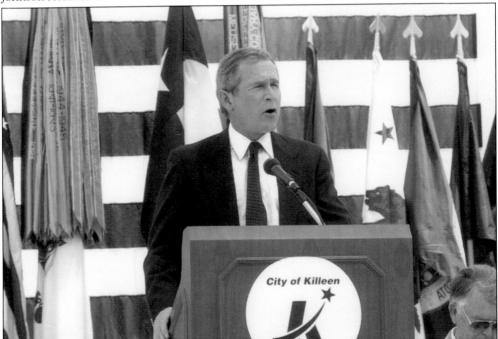

George W. Bush, then governor of Texas, spoke at a Memorial Day observance on May 31, 1999, at the Killeen Civic & Conference Center. In June, he announced that he would seek the Republican nomination for president of the United States. Bush was elected twice to the nation's highest office.

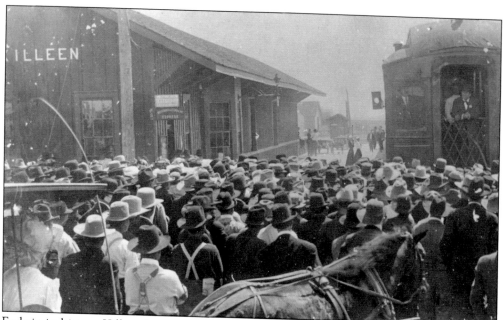

Early in its history, Killeen became a favorite stop for political candidates. In 1908, presidential candidate William Jennings Bryan gave a speech from the rear car of a special train when it stopped at the Killeen depot. Bryan was defeated in the election by William Howard Taft.

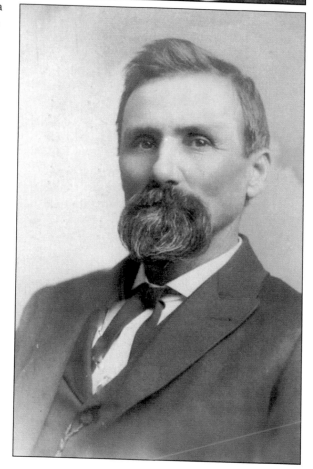

Spencer Young, a Confederate veteran, became a prominent rancher and businessman in Killeen. He had served from Arkansas during the Civil War; his unit was attached to Hood's Texas Brigade. He served as precinct four Bell County commissioner from 1886 to 1892 and was elected that year to the 23rd Texas Legislature.

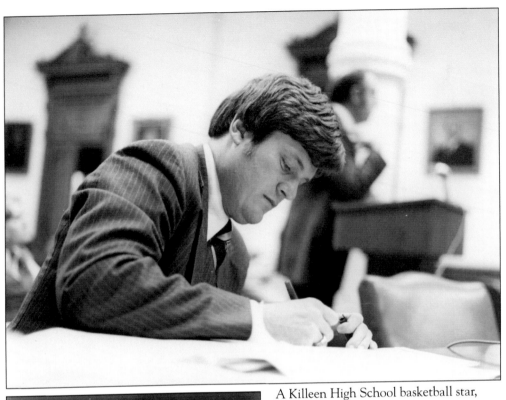

A Killeen High School basketball star, Stan Schlueter served in the Texas Legislature from 1977 until 1989 and was named one of the 10 best legislators by *Texas Monthly* magazine. He was the first Killeen resident elected to state government since the late 1800s. After leaving the legislature, Schlueter formed his own consulting firm, the Schlueter Group. Killeen's south bypass, the Stan Schlueter Loop, is named in his honor.

Growing up in Killeen, Robert M. "Bob" Gray was known as a mischievous but loved young man. As an adult, Lieutenant Gray proved to be a World War II hero when he piloted the third plane off the aircraft carrier *Hornet* in Lt. Col. Jimmy Doolittle's famous raid on Tokyo on April 18, 1942. Gray died six months later when his plane crashed in India.

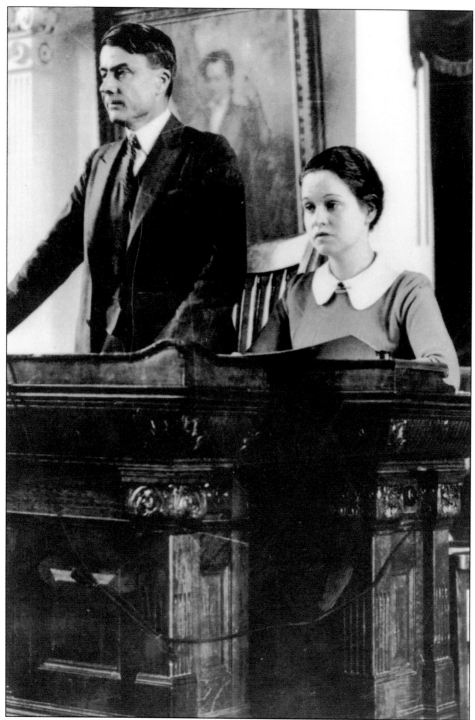

Oveta Culp Hobby, born in Killeen to I.W. "Ike" and Emma Hoover Culp, got into government service at an early age. Here, a young Oveta is pictured while serving as parliamentarian of the Texas House of Representatives during the 1931–1933 sessions. Also pictured is Speaker of the House Fred Hawthorne Minor of Denton.

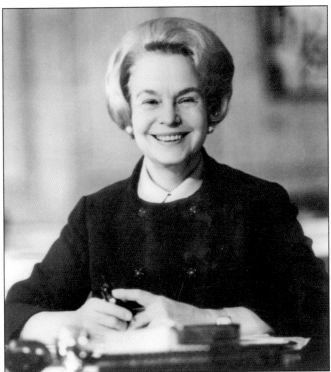

Oveta Culp Hobby, who was married to former Texas governor W.P. Hobby, was the first director of the Women's Army Corps and first secretary of the Department of Health, Education, and Welfare. She and her husband owned the *Houston Post*. They had two children, W.P. "Bill" Hobby Jr., former lieutenant governor of Texas, and Jessica Hobby Catto.

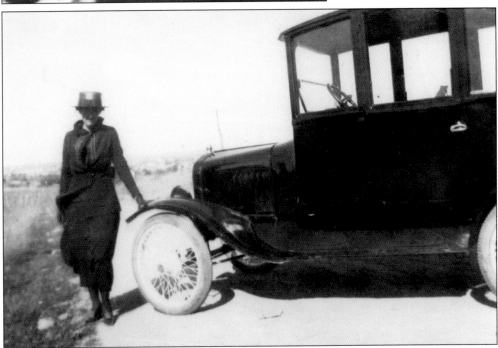

Franke Chanslor, an early independent woman, was one of Killeen's favorite citizens. She was equally at home driving her Packard through the streets of Killeen or riding her favorite mount in a city parade. Chanslor was a member of an early Killeen family that was involved in hardware and undertaking businesses.

Mid-Texas Telephone Company opened new corporate headquarters in Killeen in April 1970 on North Eighth Street. Joining in the ribbon cutting were, from left to right, John B. McDuff, president and chief executive of Mid-Texas; R.Q. Bay, Killeen's mayor; and John B. Connally, governor of Texas (1963–1969), former US secretary of the treasury, and former secretary of the Navy. Connally was wounded in the assassination of Pres. John F. Kennedy.

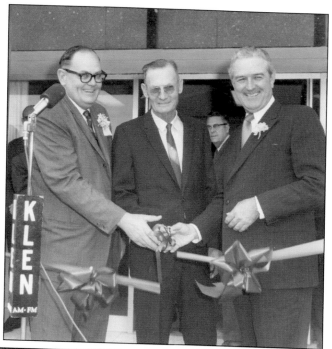

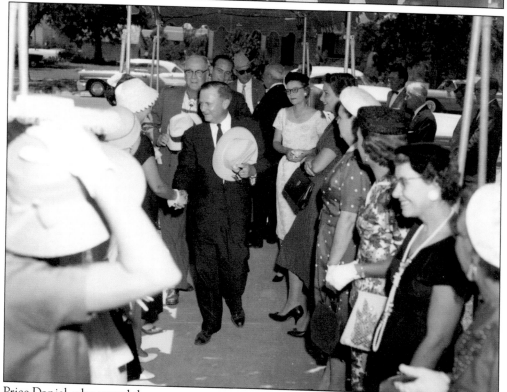

Price Daniel, who served three terms as governor of Texas (starting in 1956), spoke to the Killeen Chamber of Commerce in 1957 at El Acapulco, a former residence converted to a restaurant. Daniel, a former US senator, was defeated for a fourth term as governor by John B. Connally.

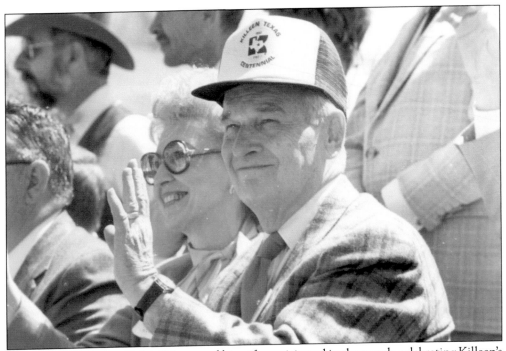

Former Texas governor Dolph Briscoe and his wife participated in the parade celebrating Killeen's 100th birthday in May 1982. Briscoe, a state leader in public service, business, and ranching, served as governor from 1973 until 1979. Briscoe's ranching operation was at Uvalde.

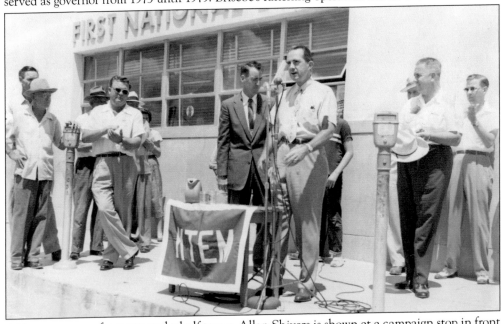

A Texas governor for seven and a half terms, Allan Shivers is shown at a campaign stop in front of the First National Bank in Killeen. Previously lieutenant governor, Shivers succeeded Beauford Jester as governor in July 1949, after the latter died in office. Shivers, who was reelected in 1950, 1952, and 1954, was so popular that he was listed as the nominee of both the Democratic and Republican parties in the 1952 election.

Texas governor Ann Richards was a special guest when Sallie Mae held a grand opening on February 15, 1995, for its expanded facility in the Killeen Business Park. Governor Richards wielded the Greater Killeen Chamber of Commerce's giant scissors to cut the ribbon. With her are, from left to right, Larry Hough (Sallie Mae's chief executive officer), Jack Hayes (vice president for operations in Texas), and US congressman Chet Edwards.

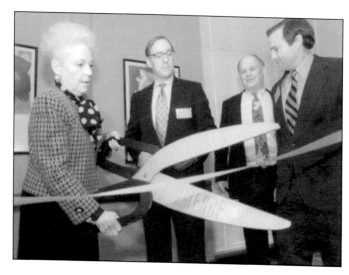

Roy J. Smith (right), who chaired the Greater Killeen Chamber of Commerce Military Affairs Committee for many years, confers with then Lt. Gen. Robert M. Shoemaker, commander of III Corps and Fort Hood. Shoemaker, for whom a Killeen high school is named, retired as a four-star general and became a Bell County commissioner. Banker Smith held numerous local positions and was a civilian aide to the secretary of the Army.

Maurice Hamilton, who operated Maurice's Barbecue for many years, was Killeen's first black businessman. He was also well known as the caterer for Roy J. Smith's backyard parties for military personnel, where he introduced many to Texas barbecue for the first time. Descendants continue to operate the popular Maurice's Barbecue, now in Harker Heights.

Killeen businessman Ted C. Connell's elevation to national commander of the Veterans of Foreign Wars brought him into contact with many national leaders. Here, he visits with Pres. John F. Kennedy. After Kennedy's assassination in Dallas in 1963, Connell served as special aide to the new president, Lyndon B. Johnson.

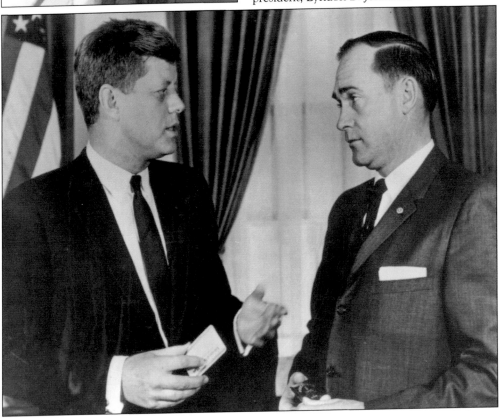

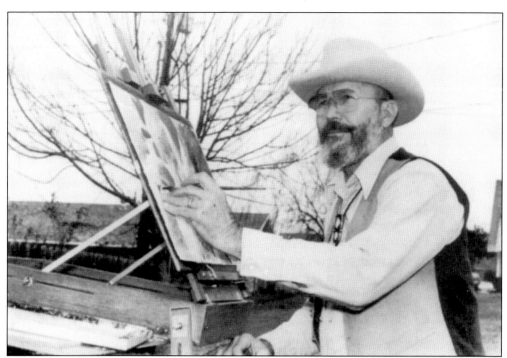

In 1981, members of the Texas Legislature named Killeen native John Carter as Texas State Artist of the Year, a role he filled from June 1, 1981, until May 31, 1982. Carter served as art director and creative director for national advertising agencies, and his business career also included managing a major national food company in New York (after which he returned to Texas).

Willie Gibson was a groundbreaker; he was the first black sergeant major at Fort Hood, and after his retirement, he opened a barbershop and in 1974 became Killeen's first black city councilman. Gibson served on the city council until 1980.

At the age of 16, Keith Fergus of Killeen defeated his father, Guinn Fergus, to take championship honors in the eighth annual Killeen Golf Tournament. Keith became a top college golfer and a successful PGA competitor before moving into the PGA Championship circuit. In 2012, he said he was winding down his tour play and going into retirement.

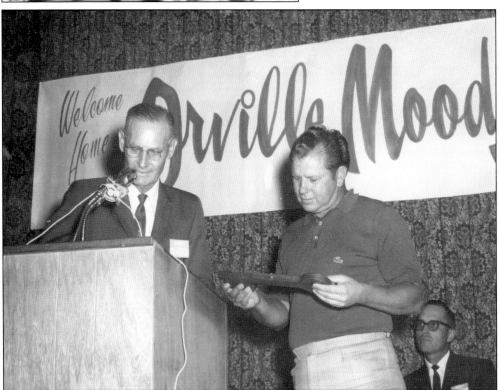

In 1969, Killeen had a special day of celebration when Orville Moody, a Killeen resident, won the US Open golf championship in Houston. Here, Killeen mayor R.Q. Bay presents the key to the city to Moody at a reception at the Cowhouse Hotel. Seated is postmaster Toby Boydstun, master of ceremonies.

Killeen's Gut Club, allegedly named by a club member's husband, met for cards and lunch in the 1930s and 1940s. Pictured here are, from left to right, (first row) Verba Woods Toliver, Jimmy Baker Nounce, Josephine Rancier Massey, Leona Kirkley, Ona Hardcastle Nills, Flo Bauchman Douglas, and Gladys Norwood Ladwig; (second row) Liz Dooley Franz, Nita Woods Jackson, Ernest Standifer Norman, Hortense Hall Lamb, and Ruby Cardwell Young.

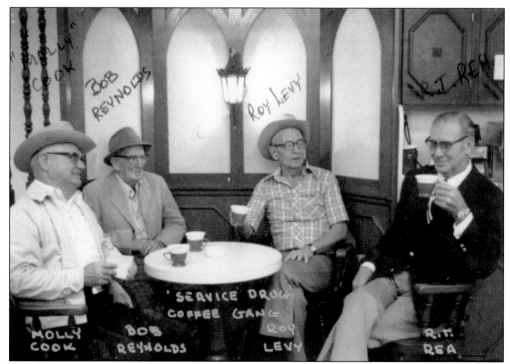

Wood's Drug Store's soda fountain was a favorite meeting place for many years, and when Wood's Drug became Service Drug Store, its "coffee gang" was made up mostly of Killeen businessmen who met there regularly for their morning break. Enjoying their coffee are, from left to right, Molly Cook, Bob Reynolds, Roy Levy, and R.T. Rhea.

Elvis Presley, who did advanced Army training at Fort Hood, arrived at the post on March 28, 1958, and remained there until September 19 of that year. During much of that time, Presley's family and close associates lived in a rented home in Killeen. Presley was considered an outstanding soldier.

Two Hollywood actors, Jane Fonda and Donald Sutherland, did not receive a warm welcome from most Killeenites when they came to the city in the early 1970s to protest the Vietnam War. Denied access to larger facilities, the two performed and led a demonstration at the Oleo Strut, a coffee house on Avenue D that served as a meeting place for those who openly opposed the war.

Seven

MEMORABLE OCCASIONS
HAPPY OR TRAGIC, KILLEEN REMEMBERS

Killeen loves to celebrate. The nation's bicentennial (1976), Texas's sesquicentennial (1986), and Killeen's centennial (1982) were all important occasions, celebrated wholeheartedly.

Killeen treasures its local events, too, some of which have survived for many years, even with name changes. Favorite traditions include Celebrate Killeen, which is the offspring of the Festival of Flags that recognized Killeen's international personality; Killeen's rodeo, which has endured for 65 years; and the 4H-FFA Junior Livestock Show, which has lasted for almost 60.

With Killeen's diverse population, numerous ethnic celebrations also enliven the calendar. Among them are the Four Winds Pow Wow, honoring Native Americans; LULAC's Hispanic festival; several South Pacific celebrations; unique Asian observances; and traditional Juneteenth activities. Additionally, Killeen's strong military ties give special significance to Memorial Day and Veterans Day observances.

But like any city, Killeen endures unhappy times, too. During the town's infancy, men regularly packed sidearms, and both a physician and a lawman were lost to gunfire. On a windy day, in March 1923, the town's elegant brick school burned to the ground. Killeen rallied, building a new brick school by 1924. It remains today as Killeen's city hall.

The worst of Killeen's tragedies occurred October 16, 1991, when George Jo Hennard crashed his pickup through a window at Luby's Cafeteria and opened fire on a large Boss's Day crowd. The result—23 people dead and 27 wounded—created a national record at the time. The shooter killed himself.

A stunned Killeen populace quickly organized in support of victims and bereaved families, and the healing process began. The following December, Killeen High School's football team won the Class 5A, Division 1 state championship, creating a temporary diversion from October's heartbreak.

Killeen experienced a similar tragedy in November 2009, when a gunman at Fort Hood killed 12 soldiers and 1 civilian, wounding 30 others. The alleged shooter's court martial proceedings began in August 2012.

Killeen's rapid growth has turned a small town into a large city, but its citizens still respond to each situation, joyful or tragic. Bonds that grow from these events make it a stronger, closer-knit community.

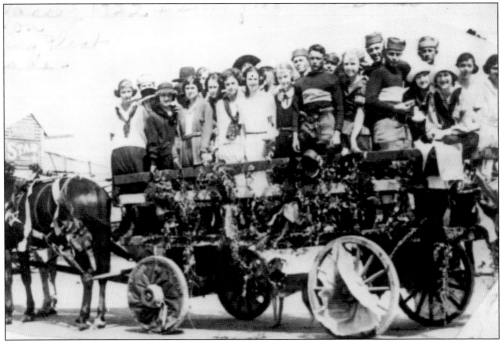

This decorated horse-drawn wagon won the top float award in a Killeen city parade in the 1920s. Sponsored by the Killeen High School senior class of 1922, the float featured members of the class along with some of the football stars. Over the years, Killeen schools and students have been major participants in Killeen's traditional parades.

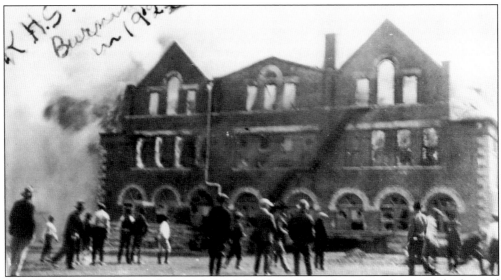

School was in session when this stately brick building, Killeen's pride and joy, caught fire and burned on a windy day in March 1923. The structure was totally destroyed. No one was injured in the fire, although some students and teachers had to exit through windows. Students attended classes in churches and other buildings until a new structure, constructed of red bricks, was completed, just south of the burned school.

A devastating flood on April 24, 1957, took three lives in Killeen. Although the heaviest damage was along Nolan Creek, flooding also hit small tributaries of the creek. This scene is on Avenue D, where water entered the *Killeen Daily Herald* and the Killeen Fire Department's first stand-alone building. *Herald* employees had to rescue several hundred copies of preprinted sections of Killeen 75th birthday edition, which had been stacked on the floor.

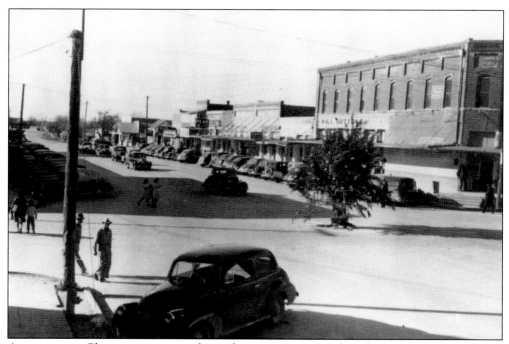

A community Christmas tree, a tradition for many years, stood in the intersection of Avenue D and Sixth (now Gray) Street. The tree was cut, hauled into town, and decorated to inspire holiday spirit. As traffic grew heavier, the tree became a hazard, and the practice ended in the mid-1930s. A live tree, just one block south, is decorated annually by Greater Killeen Chamber of Commerce Ambassadors.

Almost everyone who came of age in the 1950s remembers the drive-in movie. Ford night at Killeen's drive-in was an occasional event in which drivers and passengers in Ford vehicles enjoyed special admission. Consequently, of course, those drivers became instantly popular among their peers (at least for one night).

Bulldogging is one of the special events in the annual Killeen Rodeo, which had its 65th performance in 2012. This photograph was made during the 1962 rodeo. The rodeo is now staged in the Killeen Rodeo Arena on Bacon Ranch Road, a part of the city-owned Special Events Complex. The Killeen Rodeo Committee, sponsors, have replaced the wooden seating at the arena with metal bleachers. No more splinters for rodeo fans!

Fort Hood soldiers help firemen rescue a man from his mobile home on Nolan Creek during this 1965 flood. Scenes like this occurred often before Bell County Water Control & Improvement District No. 6 constructed flood-control dams on the creek's tributaries. The dams were completed in early 1970.

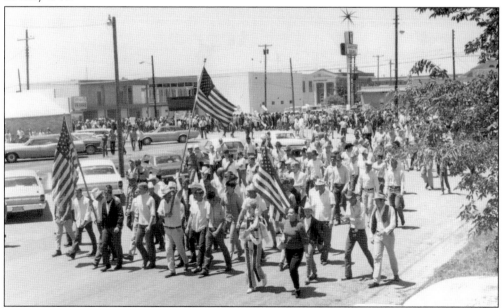

After much legal wrangling, Vietnam War protesters finally were issued a permit to hold an antiwar parade in May 1970. Killeen officials had originally denied the permit, but a district court ruled in favor of the protestors. Before protesters began their parade, another group, most dressed in western attire and carrying American flags, fell in front of them. Despite the tension, the parade went off without incident.

Killeen's 75th birthday celebration in 1957 featured a beard-growing contest. Winners were, from left to right, Al Hollinger (most unique), Derwood Berry (ugliest), Grover Black (most representative of 1880), and Bob Young (fullest). Each received 20 silver dollars donated by the event sponsor, the Killeen Lions Club.

Dr. Charles E. Patterson, Killeen's Texas sesquicentennial chairman (left), along with committee members Harriet Brodie and Gerald D. Skidmore Sr., displays the official sesquicentennial flag, used all over Texas in 1986 to celebrate 150 years since the Texian defeat of Mexican forces on April 21, 1836.

Dressed in period costumes, these four are promoting the Killeen-Harker Heights celebration of the US bicentennial in 1976. They are, from left to right, (seated) Linda Hatcher; (standing) Cecil Johnson; Betty Lain of Harker Heights, who chaired the Killeen-Harker Heights committee; and Sis Beck. The celebration included a number of activities, some in cooperation with other Central Texas communities and Fort Hood.

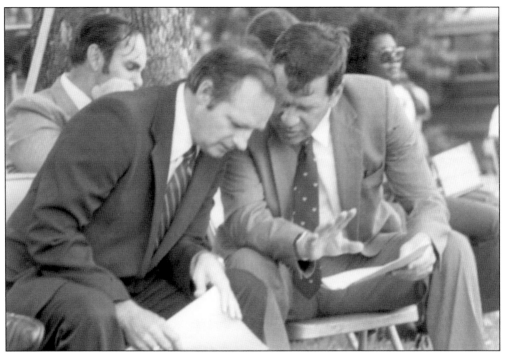

Texas lieutenant governor W.P. "Bill" Hobby (right), son of Killeen native Oveta Culp Hobby and Gov. W. P. Hobby, confers with Killeen mayor Allen Cloud prior to the dedication of a Texas Historical Commission marker, installed in Conder Park during the city's 1982 centennial celebration.

One of Killeen's most welcomed visitors during its 100th birthday celebration in May 1982 was Colum Killeen, the great-great-great-nephew of Frank Patrick Killeen, the Gulf, Colorado & Santa Fe Railway Company official for whom the city of Killeen is named. Colum is from Clare Morris, County Mayo, Ireland, Frank Patrick's hometown. Like many travelers, Colum posed for a photograph at the Santa Fe depot.

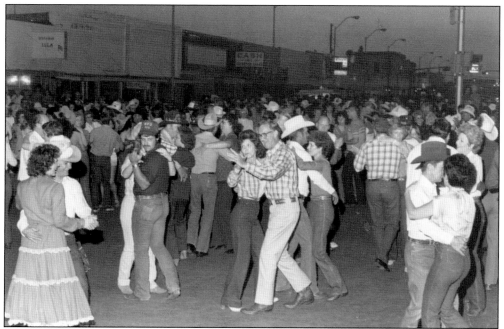

Killeen residents and guests danced in the street as part of the celebration of the city's 100th birthday in May 1982. A section of Avenue D was roped off for the well-attended event. Among the participants were Tommy Joe and Lawanna Mills (far left) and Major and Pat Blair (center).

The 1982 Killeen Centennial Committee, chaired by Cecil Johnson, held an impressive celebration during the week of May 15, 1982. Among the fundraising projects leading up to the festivities was the sale of special centennial belt buckles, designed by artist John Carter. In addition to the K logo, the buckles featured a locomotive and an Army tank, recalling the city's founding event and honoring its neighbor, Fort Hood.

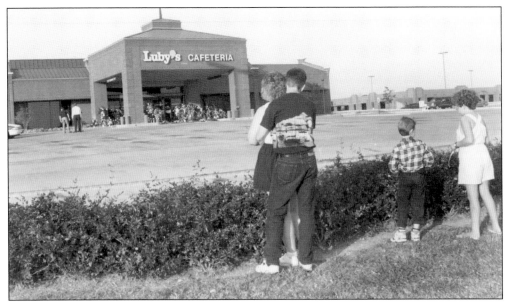

The portico of Luby's Cafeteria in Killeen was filled with flowers following the October 16, 1991, massacre in which 23 people were killed and 27 wounded. The shooter, George Hennard, crashed his truck through a window and began killing people at random. He shot and killed himself as police arrived. This family was among thousands who paid tribute to the victims of the tragedy.

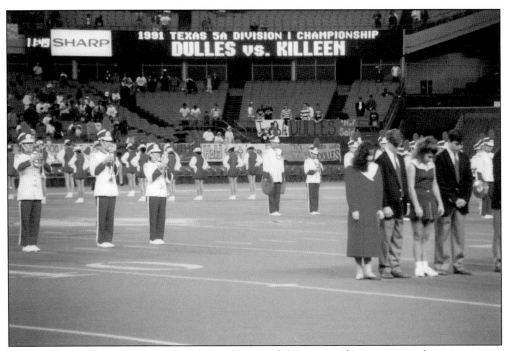

Killeen High School students, band members, and fans pause for a moment during pregame activities at the Kangaroos' state championship game in December 1991. KISD's Bob Massey took this photograph in Houston's Astrodome. Killeen won the game over Sugar Land Dulles 14-10, providing diversion for a saddened city still reeling from the Luby's massacre two months earlier.

Three Killeen police officers received medals of honor for heroism displayed during the Luby's massacre on October 16, 1991. Police chief Francis Giacomozzi (left) presented the medals. The officers, standing against the wall, are, from left to right, Charles Longwell, Ken Olsen, and Alex Morris. Luby's, located on the north access road to US Highway 190, was renovated and, as of 2012, was operating as an Asian buffet.

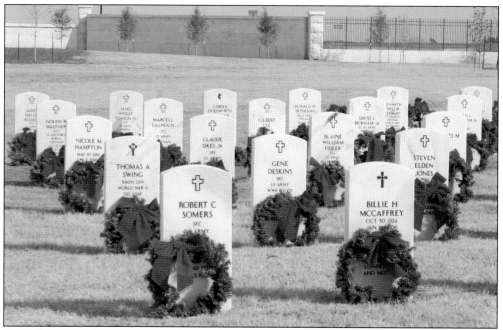

One of the ways Killeen citizens honor the large veteran population in the area is by placing wreaths on graves at the Central Texas State Veterans Cemetery at Christmastime. Numerous volunteers, young and old, go to the cemetery on State Highway 195, south of Killeen, and lay the wreaths under the direction of Friends of Central Texas Veterans Cemetery.

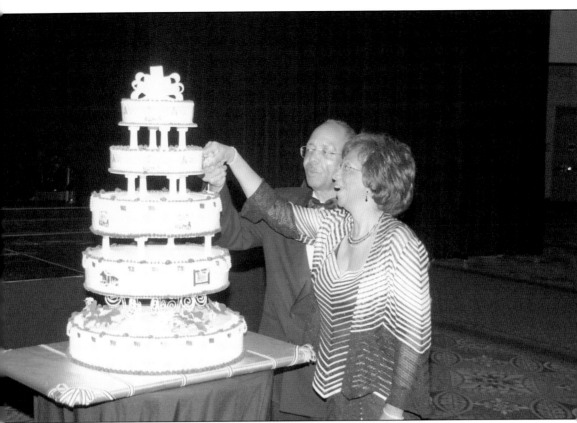

Mayor Tim Hancock and his wife, Maxine, cut a giant birthday cake at a black-tie gala celebrating Killeen's 125th birthday in May 2007. Thousands attended numerous events during the occasion, including a big party on the lawn of Killeen's city hall. Killeen was officially born on May 15, 1882, when the first Gulf, Colorado & Santa Fe Railway Company locomotive chugged into the spot railway officials had chosen for the new town.

Eight

FURTHER EXPANSION
KILLEEN CONTINUES TO MAKE HISTORY

Killeen welcomes population growth while recognizing that with it come serious challenges in providing infrastructure and services to meet citizens' needs. Every day, for example, workers and equipment can be found on Killeen's streets and highways, battling to keep abreast of the city's traffic challenges.

In the early 1960s, Killeen had no place to hold large meetings, aside from school cafeterias. Citizens banded together, raised nearly $1 million through stock sales, and built the Cowhouse Hotel. That spirit prevailed through succeeding years as other major projects were accomplished. The city now boasts a modern civic and conference center; a renovated facility for special events; an upgraded rodeo arena; a new airport, used jointly with Robert Gray Army Airfield; city hall office space, created by renovation of historic buildings; a state cemetery to serve a large veteran population; numerous new school facilities; new fire stations; and a state-of-the-art police headquarters.

The former First Baptist Church, located downtown, has been renovated and now serves as the Killeen Arts & Activities Center (KAAC). The facility provides space for the Killeen Civic Art Guild and an auditorium for performing arts, supplementing the Vive Les Arts Theatre. Also located at KAAC are the Killeen Free Clinic and a private academy; across the street is the Green Avenue Farmers Market.

Private enterprise enhanced Killeen's livability with a modern shopping mall, numerous small shopping centers, a new theater, a variety of traditional and ethnic restaurants, and other major retail opportunities. Real estate developers have kept pace with growth by providing sufficient affordable housing.

Health services get a boost from continual expansion of Metroplex Hospital, which serves the Killeen and Copperas areas, as well as the growth of clinics and specialty medical services.

Educational opportunities for Killeen-area residents continue to expand. The area boasts the largest public school district between Austin and Dallas and higher educational possibilities that reflect the city's historic emphasis on learning.

Rapid growth of religious organizations is meeting spiritual needs of the community, with many smaller denominations building new structures or leasing existing ones and larger congregations leaving the downtown area to build more modern facilities in suburban areas.

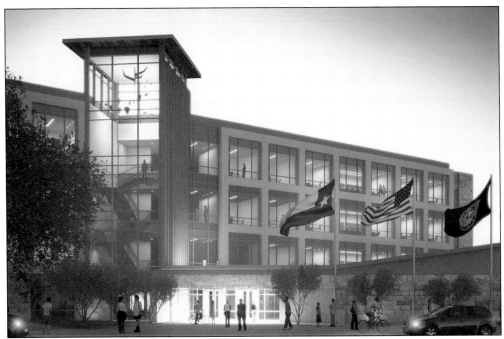

May 24, 2012, was a red-letter day for Texas A&M University-Central Texas; it was the day a ribbon-cutting ceremony was held for the first building on the university's 662-acre campus. Immediately following that event, a ground-breaking ceremony was held for the second building at the campus, located off State Highway 195. Texas A&M-Central Texas, which opened in the fall of 2009, is a branch of the Texas A&M University system.

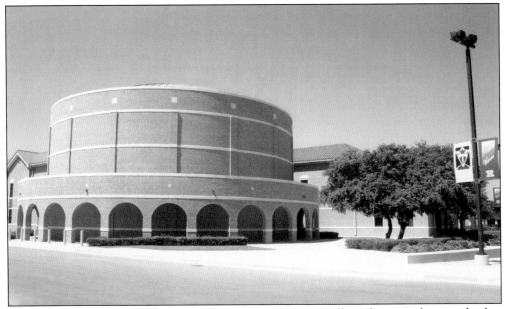

Mayborn Planetarium & Space Theater at Central Texas College draws students and other visitors from Central Texas. The theater is a state-of-the-art facility that hosts planetarium shows, large-format films, and digital laser light shows. Opened in 2003, it welcomed more than 100,000 visitors in its first seven years.

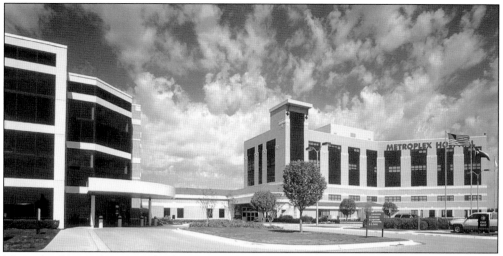

Metroplex Hospital, a part of Adventist Health System, is located on South Clear Creek Road just off US Highway 190. Establishment of the major medical facility was a joint effort between Killeen and Copperas Cove. Metroplex Hospital, opened in October 1978, continues to grow in size and health care offerings. It has nearly 1,200 employees and more than 300 physicians practicing in 48 specialties.

After several years of planning, the Killeen Civic & Conference Center opened on April 26, 2002. The 63,000-square-foot center on South W.S. Young Drive includes a hall that will seat 750, banquet style, or 1,400, theater style. It also can be converted to smaller meeting rooms. Six other rooms can seat 25 to 50 people each, and a special events room can seat 125, banquet style, or 250, theater style.

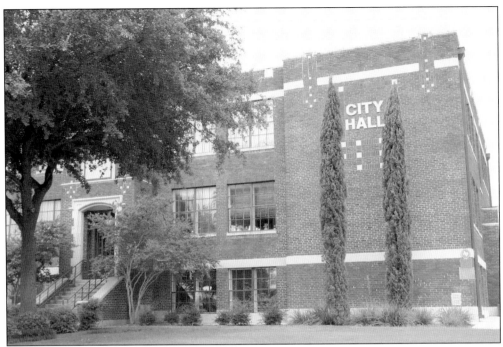

For most of its existence, this building served as Killeen's only school. Generally known as Avenue D School, it was built between 1923 and 1924 to replace a structure that had burned. When Killeen Independent School District quit using the building as a school, it was turned over to the City of Killeen for renovation. It was dedicated as Killeen City Hall on April 30, 1995.

On August 4, 2004, Killeen-Fort Hood Regional Airport opened on the east side of Robert Gray Army Airfield. With agreement for joint civilian-military use of the Army's airport, Killeen built a separate taxiway and a $24-million passenger terminal. The airport offers nonstop direct air access to Dallas/Fort Worth, Houston, and Atlanta airports.

Killeen's second center for senior citizens opened in Lions Club Park on Stan Schlueter Loop in 2007. The Killeen Senior Center has 14,000 square feet and includes a ballroom with platform (stage), offices, and special rooms for arts and crafts, billiards, and exercising. It also has a living room with a library. Bob Gilmore Senior Center, located at the Killeen Community Center with city ballparks and a hike-and-bike trail, also continues to serve residents.

Killeen Family Recreation Center, opened in 2007 in Lions Club Park, features 41,000 square feet of floor space and includes a teen game room, weight and exercise room, gymnasium, indoor track for walking or jogging, and locker rooms. Professional football player Tommie Harris of Killeen donated equipment for a first-class fitness center.

The City of Killeen has converted the former First Baptist Church on North Second Street in the downtown area to the Killeen Arts & Activities Center, whose grand opening was held on April 30, 2012. The facility grants Killeen additional meeting space, including the former Clarence Clements Chapel, pictured here, which was donated to the First Baptist Church by banker Clarence R. Clements.

The Killeen Family Aquatics Center provides water recreation for all members of the family. Located in Lions Club Park, the center opened on July 25, 2009. It includes four waterslides, 10,000 square feet of connected pools, a pavilion, and several water spray features. Another spray park is located in Long Branch Park on Rancier Avenue. Both facilities are operated by the City of Killeen Parks & Recreation Department.

Killeen Municipal Golf Course underwent extensive renovations in the early 2000s and reopened in 2005 with several new greens, a new clubhouse, new pro shop, additional parking, more cart storage, and a new name: Stonetree Golf Club. The course, which originally opened in August 1970, is located in east Killeen between Skylark Field and the Harker Heights city limits.

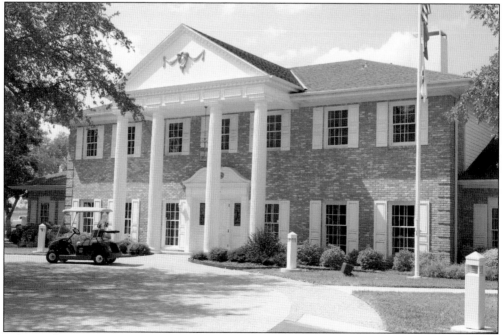

When Killeen renovated its municipal golf course in the early 2000s and renamed it Stonetree Golf Club, it also purchased a Colonial-style, 8,000-square-foot residence to be converted into a clubhouse. The new clubhouse, on the western side of the golf course, contains the pro shop and also has facilities for parties, weddings, receptions, and other social events.

A new home for the Killeen Police Department opened in 2010 on Featherline Road, near the intersection with Chaparral Road. The up-to-date headquarters contains 80,000 square feet of floor space and includes a jail. A small force and administrative offices remain at the previous location on Second Street and Avenue C in the downtown area.

Killeen was selected as the site for Texas's first state veterans cemetery. Texas State Veterans Cemetery was dedicated on October 5, 2005. The cemetery is located south of Killeen on State Highway 195 and covers 174 acres of land, formerly part of Fort Hood. When fully developed, it will have 50,000 burial plots. This photograph shows the cemetery's entrance.

KISD's Career Center, serving students from all the district's high schools, opened in fall 2012. The 42,000-square-foot center, located on Stagecoach Road just off Trimmier Road, allows students to train for careers in nine areas, such as health science, information technology and communications, transportation, and construction.

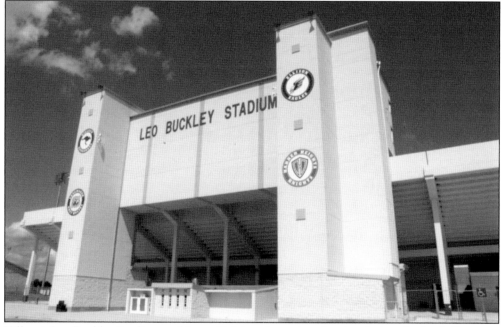

Killeen's Leo Buckley Stadium and its artificial turf see a lot of action during the football season. The 7,600-seat stadium, photographed by KISD's Todd Martin after several expansions, is the football field for four high school teams: the Killeen High School Kangaroos, the Ellison High School Eagles, the Harker Heights High School Knights, and the Robert M. Shoemaker High School Grey Wolves.

Killeen shoppers were excited to see construction of Killeen Mall under way in 1980 on a 73-acre tract of land on South W.S. Young Drive at US Highway 190. The mall features four anchor stores and more than 100 other retail and professional businesses. A number of other buildings were later added around the perimeter of the complex.

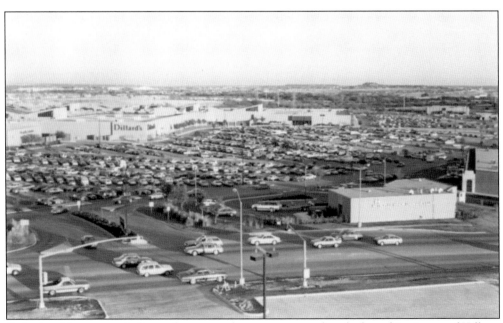

Packed parking spaces indicate that many shoppers were on hand when this picture of Killeen Mall was taken in December 1986. The mall, whose construction was announced on October 5, 1978, opened with a large crowd in attendance, on March 25, 1981. In remarks at the opening, Killeen mayor Major Blair called it his "happiest day as mayor."

A fixture in Killeen since 1981, Wal-mart has upgraded its facilities to meet a growing customer base. First located on the access road of Highway 190, Wal-mart moved to a larger facility on Lowe's Boulevard in 1999. Bob Sykes, store manager, is shown cutting the ribbon to mark the opening of a remodeled and much expanded store in 2009.

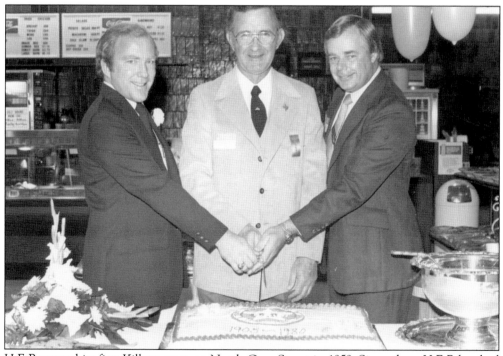

H-E-B opened its first Killeen store on North Gray Street in 1959. Since then, H-E-B has had three other locations. This cake-cutting ceremony was held at the former Wendland Plaza store in celebration of the H-E-B chain's 75th anniversary. Pictured are, from left to right, store manager Don Schmidt, Killeen mayor Major Blair, and district manager Roy Schmidtzinsky. Current stores are H-E-B Plus on Trimmier Road and the original store on Gray Street.

In 1980, Vive Les Arts Societe formed Vive Les Arts Theatre. Under the direction of Ron Hannemann, the theater boasted 10 blockbuster seasons before outgrowing the renovated 1914 Texas Theatre downtown. This new facility on W.S. Young Drive opened in January 1991 and featured a 400-seat auditorium, a proscenium stage, lobby/art gallery, parlor, and administrative offices.

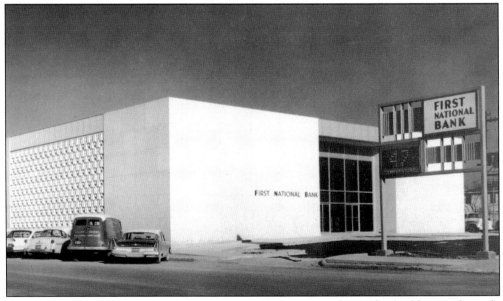

First National Bank Texas, founded on February 27, 1901, moved into this building in the early 1960s. The location, which has seen renovations and additions, still serves as headquarters for the bank. With the addition of the First Convenience Bank division, First National Texas has expanded its operations outside Texas to include Arizona and New Mexico. In 2012, it reported having 281 bank branches and 394 ATMs.

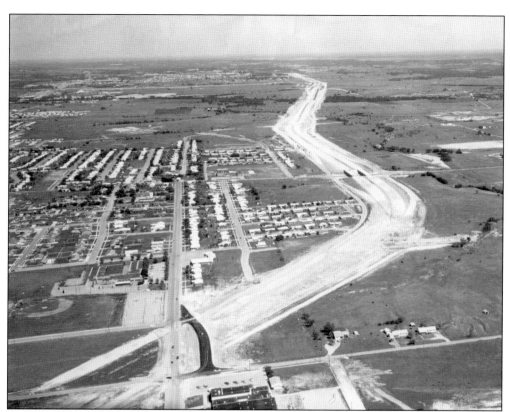

Killeen's heavy traffic got welcome relief in 1976 when US Highway 190, built to near-interstate standards, opened. The $30-million project began with a ground-breaking ceremony in May 1971. This Bob DeBolt aerial photograph shows the highway under construction, running between Bellaire Elementary School (lower center) and Nolan Junior High School (lower left). The new road extended from Copperas Cove to Interstate 35 in Belton.

In the early 1990s, FM 440—a busy (and dangerous) highway leading south out of Killeen and connecting with Interstate 35 at Georgetown—became State Highway 195, making it eligible for better funding. It has been greatly improved in the past few years and is now being made a four-lane, divided highway for its entire length. Here, a workman erects one of the road's new signs.

Killeen got a second nearby lake when Stillhouse Hollow Lake was completed in July 1968. The US Army Corps of Engineers project was constructed on the Lampasas River to provide flood risk management, water supply, and recreational opportunities. Located southeast of Killeen, the lake area covers 10.05 square miles. Construction work on the dam is shown in this photograph.

Lake Belton supplies water for the city of Killeen and Fort Hood, in addition to other cities and water districts in the area. The scenic lake, completed in 1954, provides flood control and is an excellent spot for recreational activities, including all types of boating, fishing, scuba diving, and swimming. The $17,191,734.04 project is on the Leon River, west of Belton and northeast of Killeen.

...day, the historic Jeweler's Bank building at the corner of Gray Street and Avenue D hosts ...ew downtown business with a name, Tank's Pub, that reflects Killeen's "tale of two cities" ...cription. Forming a vibrant link to the past, it serves customers very much in the present, ...uding active-duty soldiers, veterans, and their friends.

Discover Thousands of Local History Books Featuring Millions of Vintage Images

Arcadia Publishing, the leading local history publisher in the United States, is committed to making history accessible and meaningful through publishing books that celebrate and preserve the heritage of America's people and places.

Find more books like this at
www.arcadiapublishing.com

Search for your hometown history, your old stomping grounds, and even your favorite sports team.